W9-ATU-109

WATERCOLOR & ACRYLIC PAINTING MATERIALS

By William F. Powell

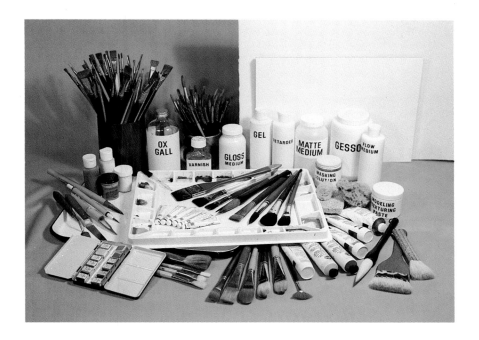

Walter Foster Publishing, Inc.
23062 La Cadena Drive, Laguna Hills, California 92653

CONTENTS

INTRODUCTION

Before beginning to paint, an artist must consider all the tools and materials that are required. It doesn't matter what the chosen medium — watercolor, acrylic, or oil — each has a basic set of tried, tested and proven tools and materials.

Some media, such as oil paints, are quite complex in the areas of gels, thinners, painting mediums and varnishes (see *Oil Painting Materials And Their Uses*, also published by Walter Foster). Fortunately, watercolors and acrylics are much simpler. There are a few tools that are used just for one of them, but in most cases, the same tools can be used for both.

This book is divided into two sections: watercolor and acrylic. When necessary, the tools, materials, and descriptions have been divided for clarity. However, some descriptions and examples will show or explain the capability of a tool being used for both media.

Some materials used for special effects are referred to as "gimmick" tools. But if thoughtful application of a tool or material is practiced, the word "gimmick" does not apply. An artist should never be afraid to experiment and search out new avenues and approaches to their chosen medium. However, understanding the materials being used is of utmost importance. It would be foolish to introduce an ingredient that would erode the paint or support as the painting ages. That is why those of us who are intrigued and involved with the visual world of painting are constantly learning and searching for the most permanent materials to use.

In this book, only proven materials are discussed. Over the years I have tested and experimented with many mixtures and techniques. As stated in my book, *Oil Painting Materials And Their Uses*, I used the flat, Spanish-style roof of our home as a testing ground for many media, varnishes, etc. This also included watercolor materials. After becoming acquainted with the materials in this book (which covers all of the usual ones needed by the watercolor painter), try some experimenting of your own. It can be very interesting.

Some artists prefer the spontaneity of watercolor and acrylic over oils and other slow media because it allows them to make their brush statement immediately and then go on to the next step without waiting for drying time. They feel that this medium keeps them fresh and vibrant in their work. Give it a try; push that color around; let painting be fun!

I truly hope that this book will accomplish the following:

- Introduce and acquaint the reader with the different tools and materials used in the art of watercolor and acrylic painting.

- Explain how these tools are used through simple, but thorough explanations, diagrams, sketches, photo illustrations, and sometimes combinations of all.

- Act as a materials reference guide for the student, hobbyist or professional.

- Answer the many questions that arise during the first steps of using a new tool.

- Correct misunderstandings of any tool or material and their intended functions in watercolor and acrylic painting.

- Dispel any misinformation regarding the use of materials and chemicals not refined for both of these mediums.

INTRODUCTION TO WATERCOLOR

Watercolor paint is made of finely ground pigment that is suspended in a water-soluble binder — gum arabic. Gum arabic is a sap that is gathered from trees in tropical climates. It dries hard and is insoluble in turpentine, petroleum thinners and alcohol. It is, however, readily soluble in water which makes it the perfect binder for watercolors.

Unlike some other media, watercolor is used with transparent technique. This technique uses the white of the painting surface as the light instead of mixing the colors with white pigment to obtain tints of color as with oil paints. Transparent glazes are laid over one another on the paper to obtain various degrees of depth and color. The white of the paper is more brilliant where the glazes are fewer and thinner. Note — There are a few instances where a pure white pigment (Chinese White) is used for color and tonal effect, but the true and pure watercolor painting contains no white or opaque paints of any kind; it is totally transparent.

Watercolors are referred to as "aqueous" paints. This means that they contain or are diluted by water. The term "aquarelle" distinguishes a transparent watercolor painting from an opaque one done in a medium such as gouache or acrylics. Some manufacturers of art materials have adopted this term as a name for their watercolor products and tools.

Watercolors can be used with other water-based paints and media and are an excellent under-painting medium for oils. They should never be painted over oils, but are commonly used for the underpainted layout for oil paintings. A basic rule to remember is that oil will adhere to watercolor, but watercolor (or any other water-based paints) will not adhere to oil.

Watercolors are considered a permanent painting medium; the old tale that watercolors will fade when exposed to sunlight is false. Only the few colors that are not considered lightfast will fade. When framed properly, preserved under glass and displayed under normal conditions, watercolor paintings will normally not fade or lose brilliance.

A watercolor painting is produced through a number of steps. First, a precise, light pencil drawing of the subject is done on the paper. The colors are then painted onto the proper areas of the draw-ing in very thin washes. The paint is applied directly onto wet or dry paper, depending on the effect desired. Wet paper allows the color wash to "float" on the surface freely; dry paper allows for more tight and disciplined control of color in specific areas. The painting is worked from light to dark, leaving very thin washes where more light and delicate tints are desired. More washes and glazes create deeper tones and color mixtures. The wet-in-wet technique produces some very beautiful and interesting results that can be used for backgrounds, foggy and misty scenes, skies, and much more. The color is far less controllable with this technique and the selection of colors to be used must be planned and manipulated thoughtfully.

All in all, watercolor is a less complex medium than oils, but it is also less forgiving of mistakes. The oil painter can wipe out or paint over an unwanted area, but once watercolor is laid down it can only be manipulated a few different ways and sometimes cannot be totally removed. Watercolor is an exciting medium with an endless variety of techniques possible. The resulting freshness of color can be brilliant and beautiful.

As with other media, the brushes used for watercolor and/or acrylic are probably the most misun-derstood of all the tools. For this reason, we will begin with them. There are so many types of hair, bristles and styles available that a beginner can become utterly confused as to which brushes to buy and which brush to use for which purpose.

It is not necessary to purchase all types of brushes in the beginning. The best approach is to start with just a few simple ones. After we have mastered these, we can then add to the supply. Many professionals work with just a simple selection of their favorite brush types even though they may have many.

WATERCOLOR BRUSSHES

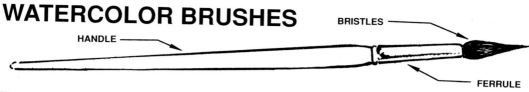

HANDLE —

BRISTLES —

FERRULE

There are three major parts of a brush: the handle, the ferrule and the bristles. Although all brushes are basically made the same way, many styles and qualities are available. They vary in shape, size, and, most importantly, the materials used to make each one. Each style of brush is designed to perform specific tasks. This depends on the material used for the bristles, the length and taper of the bristles, the depth of insertion into the ferrule, and the shape of the handle. Watercolor brushes are made with short handles, while oil painting brushes made with sable and other natural soft hair have long, slim handles and those made with bristle usually have long, heavy handles (depending on the width of the brush).

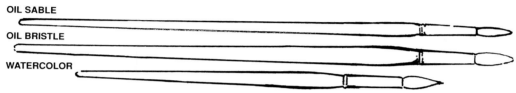

OIL SABLE

OIL BRISTLE

WATERCOLOR

The prices of brushes vary greatly. This depends on the type of hair or bristle, and the craftsmanship used in producing the brush. Brushes containing the finest sable hair are quite expensive. The finest hair and bristles are selected for their lasting quality, toughness, flexibility and memory for springing back, and the proper thickness, point and taper of each hair in relation to all other hairs used in the same brush. The ability to spring back to its original shape is the most important factor. The finest watercolor brushes will spring back to their original shape even when loaded with water.

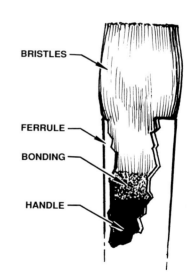

BRISTLES —

FERRULE —

BONDING —

HANDLE —

The fine hair and bristles used in watercolor brushes are hand-sorted and combed, then set so that each one will achieve the desired length, quality, strength and thickness. They are then placed into the ferrule by hand, glued to the handle and crimped.

There are a number of brushes available for watercolor painting that are not as expensive as the very finest, but they often perform just as well while we are learning. (Note — some of the finest red sable brushes cost several hundred dollars each.) It is always wise to buy the very best quality you can afford, but, again, the less expensive brushes work well for beginning practice. In fact, some artists prefer brushes that are made with either all synthetic or a blend of natural and synthetic hairs.

When using watercolor and acrylic paints, both natural and synthetic hair brushes can be used. However, care must be taken to never allow acrylic to dry in the brush, especially a natural hair brush, because if it does the brush will probably be ruined forever. Acrylic has a tendency to cling to the natural hair and is difficult to remove. It slides easily from the brushes of synthetic fibers such as nylon.

For clarity of presentation, standard inch measurements will be used to describe the brush sizes because brush makers do not adhere to a standard width for the same number of brush. For example, a #20 soft hair bright-style brush can vary as much as one-half inch in width from maker to maker.

Natural Hair Brushes

The performance of a brush is affected by the type of hair or bristle used and the depth and attitude that the hairs are set into the ferrule. Usually, the deeper the hair is set into the ferrule, the stiffer the brush feels and the more memory and resiliency it has.

There are basically two types of natural hair used: one is soft hair, the other is stiffer and is referred to as "bristle." There is quite a range of quality and sources for both types. The ideal hair and bristle must meet certain specifications.

The natural ends of the hair or bristle are set so as to form the style of brush. They will form the tip of the flat or filbert-style brushes and the point of the round one. These ends are never cut in the finest brushes; it is far better to paint with the natural tip. In some inexpensive brushes the ends are cut to achieve a uniform length. These will never perform as well or give as fine a chisel tip as those that are not cut.

Each style of brush has its own name; we will study these styles as we go from brush to brush. As an introduction, however, notice the different shapes of the basic set of brushes in the illustration.

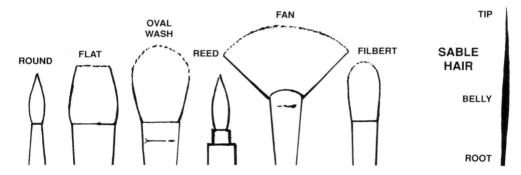

Soft Hair Brushes

Soft hair brushes are used more often for watercolor painting than the stiffer bristle type are. They are considered the basic tools for watercolor since they can be used for broad washes as well as delicate areas of detail. Soft hair brushes come in styles from tiny pointed rounds to big, floppy wash brushes.

These brushes are made with the hair from a variety of different animals which range from pure red sable to ox, badger, skunk, fitch, squirrel, horse, and even monkey. A camel hair brush is made with hair from various animals, but not the camel. It is often a blend of several; squirrel is most common. The better brushes are made with hair that has proven to be the best for the purpose through years of application. The tips of the soft hair sables, unlike the flagged tips of the bristles, taper to a very sharp point. The body of the hair shaft bulges around the middle. This is referred to as the "belly" and is the widest part of the hair. The hair tapers back down to a slender width at the root.

The root end is set into the ferrule. Generally, the longer the length of hair that is set into the ferrule, the more spring the brush has. Some brushes are set with the belly of the hair just starting to protrude from the ferrule. The hair in oil brushes is set in a more slender style, while watercolor brushes are made with a bulge using the belly of the hair.

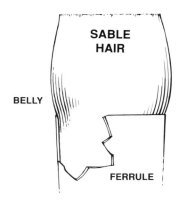

SABLE
HAIR

BELLY

FERRULE

The best type of soft hair brush is the pure red sable. The hairs taper gently and come to a fine point. These hairs are cut from the tail of the kolinsky — an animal in the mink family which is found in Siberia and various parts of Asia. The fur of this animal's tail is selected because it has all the required characteristics to make the finest brush of its kind.

After selection, the hair is combed by hand and all of the bent or misshapen hair is removed. The hair then goes through a gentle heating process to remove any grease present without losing the natural oils or destroying the flex or resiliency. These hairs are then sorted for uniformity of length and formed into a brush by the hands of a skilled brush maker. They are set into the ferrule with a vulcanizing compound and crimped onto the wooden handle.

Bristle Brushes

A watercolor artist will often carry a couple of stiff bristle brushes that were originally made for an oil painter. These brushes are made with white hog bristles and can be used for scrubbing out areas of color or for creating various textures and patterns. They are much stiffer than the soft hair brushes and each bristle has a flagged end that grips the other ends, creating a brush that will carry lots of heavy paint. We do not use paint in this manner for watercolor painting, but we can still employ them as rough working tools. The flat, the filbert, the extra-long filbert, and the round brushes shown here are effective tools which can be used by watercolorists in many instances.

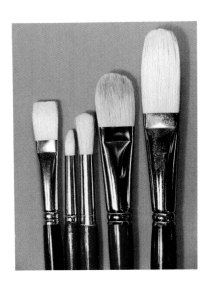

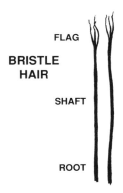

FLAG

BRISTLE
HAIR

SHAFT

ROOT

The flagged tips of bristle allow this brush to carry large loads of paint for oil painting. Here we see that they are also able to remove wet color from watercolor paper by dragging the tip of the brush over the color. Good edge control is possible due to the stiffness of the brush. This technique can also be accomplished on a dry area with a wet brush as long as the dry colors are non-staining (see page 32).

Sabeline Brushes

The original name "sabeline" referred to brushes made with the highest quality ox hair and dyed to resemble pure red sable. Today, however, with the availability of delicate synthetic fibers, the name is sometimes used to describe not only brushes made of ox hair, but also those made by combining pure red sable with other hair such as ox, badger, squirrel, etc. In addition, it is used to describe brushes that are combination brushes. These combination brushes are made by combining pure red sable, ox or other natural hair with synthetic hair. There are some very fine brushes in this combination category. A combination of synthetic hair and black squirrel hair makes a nice brush for watercolor. Most sabeline brushes can be used for the same painting tasks as pure red sables, but they are less expensive. They are available in most of the same styles as in the previous listings. These brushes also perform well with acrylic, but they must be kept wet.

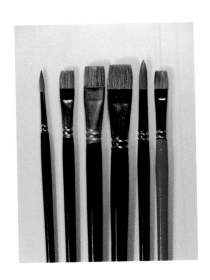

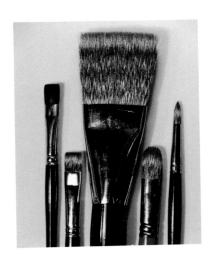

Lesser Sables

There are a number of brushes labeled "sable" that are not made of pure red sable. These are either a lesser grade of sable hair or are made from ox, badger, etc. They are available in most of the same styles as soft hair brushes and work well as a substitute for the more expensive pure red sable (they are also great for classes and experimenting).

Synthetic Hair Brushes

Most natural hair brush styles are available in synthetic hair also. Synthetic hair brushes are less expensive than those of natural hair, but they perform well with watercolor or acrylic and, in some cases, have more spring-back than sables. Acrylics have a tendency to cling to the sides of natural hair bristles and will often set even while the brush is being used. Synthetic hair brushes were created with smooth, slick bristles which helps the acrylic to slide out of the brush.

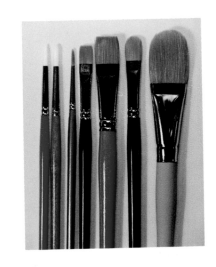

There is also a variety of names (i.e., taklon, rislon, etc.) given to the types of synthetic hairs and bristles used to make these brushes (many are nylon). Each manufacturer places its own house brand name on its brushes.

Some of the less expensive lines of synthetic brushes have a tendency to flare out at the end when used with oil or if not well cared for and cleaned properly. If this happens, don't throw them away; use them as texturing tools for grasses or bushes, or as scrub-in brushes. Also, a synthetic brush can sometimes be reshaped by gently using heat or hot water. This is not always possible, but it is worth a try.

Some professionals prefer all natural hair, some a selection of both natural and synthetic, and some use only the new, all-synthetic hair brushes. I use a selection of natural hair, combination blends of natural and synthetic hair, and a few all-synthetic bristles. After becoming acquainted with several styles and types of brushes one might wish to add the more specialized styles such as washes, mops, fan brushes, etc.

Combination Brushes

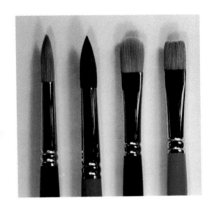

Brushes with a blend of natural and synthetic hair are also available. These perform beautifully and are worth the effort that goes into making them. Some have more spring than others, so one must experiment to find the types preferred. By combining both natural and synthetic hairs, the brush manufacturer is giving us the best of both worlds in one brush. A little more care must be used when cleaning these brushes as the natural hair will hold onto acrylic and sometimes clog the brush. A number of these brushes are made for oil painting, but they are good for other media as well, including acrylic. They are available in the same sizes and styles as natural hair brushes.

BRUSH STARTER SET

The following list of brush styles and sizes make a good starter set. This list could be reduced to even fewer by selecting a basic set of one round, one 1" watercolor wash brush, and one larger wash brush. If you prefer to begin with pure red sables, feel free to do so, but a selection of bristles and hair types is a good idea. Not only is it less expensive, but it also gives us a chance to feel the difference of each type and decide which ones we prefer for future painting. For this reason, a variety of hairs and combinations of hairs are shown in the photo.

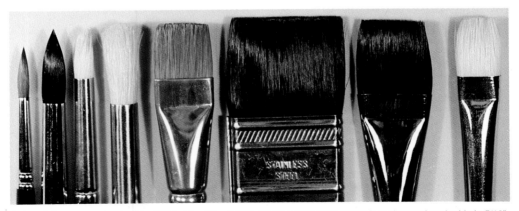

Left to right are: round red sable, 3/16" wide at the ferrule; round combination synthetic and natural squirrel hair, 5/16" at the ferrule; round white hog bristle, 1/4" wide; round blunt-end hog bristle, 3/8" wide; bright-style red sable, 3/4" wide; flat-style wash combination synthetic and natural squirrel hair, 1-1/2" wide; 1" watercolor combination synthetic and natural squirrel; bright-style white hog bristle, 5/8" wide.

All the brush styles shown in the photo are available in each hair type: sable, sabeline, combination, and pure synthetic. These are shown as examples only. In the following section on brushes each style will be discussed thoroughly. It is best to read this section before deciding which type of hair or bristle to try first.

BRUSH STYLES AND THEIR USES

Rounds (Pointed)

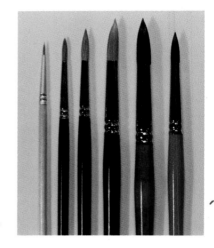

The finest round watercolor brush should taper gradually to a fine point. This makes the kolinsky sable the most sought after, but it is also one of the most expensive. There should be a smooth taper and a bulge caused by the belly of the hair. This bulge allows the brush to absorb an ample amount of paint. The point is very fine and used for detail.

When discussing soft hair rounds we must consider the large variety of other hairs available. The hair used in the type called "camel hair" has little or no memory for spring-back. These are not used for general painting, but some can hold large amounts of water which makes them useful for applying washes. Brushes made of ox, badger, skunk and synthetic fibers or blends of both are good substitutes for the expensive pure red sable. The pointed round is capable of a great variety of strokes. By changing the pressure on the brush and the consistency of the paint, very tiny lines as well as broad strokes are possible. It is good to start with two round brushes — one of the largest size affordable and a smaller one for detail.

Shown above are: three red sables (the very small one is for detail), the fourth is a combination of natural and synthetic hair, and the last two are combinations of squirrel and synthetic hair.

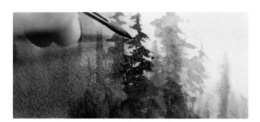

By pressing lightly with the tip of a pointed round brush, very fine detail is possible. Tree branches are being painted here.

By tapping the brush against a stick, paint is splattered onto the painting surface creating the illusion of beach pebbles. The paint must be thin for this technique.

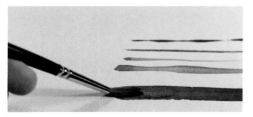

A wide variety of line widths is possible by varying the pressure on the brush. A firm touch creates wide lines; a light touch makes thin lines.

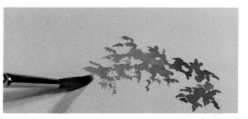

Tiny leaves can be stamped on with the end of the brush. By changing the angle of the brush, we paint the loose, free feeling of leaves.

Rounds (Blunt-Ended)

Blunt-end round brushes are usually less expensive than the pointed rounds which are made with pure red sable hair. Blunt-end rounds are often made of lesser quality sable. These brushes will create broad blends and strokes while maintaining the soft touch of the pointed round. They also allow for large loads of paint to be brought to the paper for wet-in-wet work. The hairs are set into the ferrule so as to make a rounded tip rather than a fine point. This tiny rounded tip can be used for stamping effects and for other things such as feather work.

Blunt-end rounds are available in sizes from 1/16" ferrule width and up. Pointed rounds are available in sizes from 1/16" to 3/8" ferrule width for general painting. There are larger sizes available at additional expense.

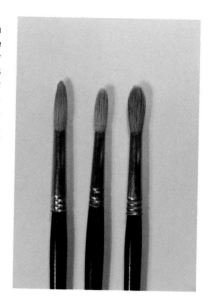

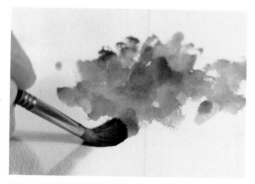

Blunt-end rounds and worn down pointed rounds can be used with a gentle scrubbing motion to apply an uneven, but controlled area of color.

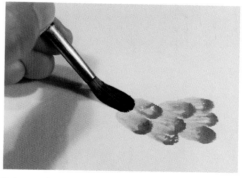

Flat stamping the brush makes marks that resemble feathers. Double loading (one color on the tip, another deeper) will create flower petals.

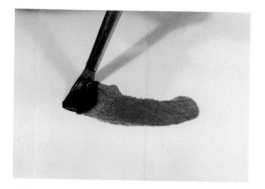

With a large load of color, wide sideways strokes are made. Do not press too hard or the brush will grip the paper and the width will be lost.

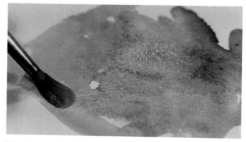

Wet-in-wet blends of various colors can be applied with this brush. Notice the spread of the tip of the brush as it is being pulled across the painting surface. There are many loose techniques that can be accomplished with the round-style brush. Experiment with stroke and color and create some of your own.

Brights

The bright is a rectangular shaped brush with shorter hair than some of the other soft hair brushes. These shorter hairs give the brush more strength for pushing wet color around or for pressing into color to lift it away. This type of brush is probably used more by the oil painter than the watercolorist, but it has its advantages for both. Not only can it carry a large load of paint to the painting surface, but its sharp corners are great for painting details and other fine work. This brush will form a fine chisel at the end, allowing thin lines to be drawn. Because of its stiffness, textures may be obtained that are not possible with other brushes. The bright should have a good memory for springing back to its original shape; this adds to its importance. It is a versatile brush and many illustrators use it as a general painting brush because of the detail and control obtainable with it. The bright is available in a range of sizes, from 1/8" to 1" for general painting. There are larger sizes available by special order.

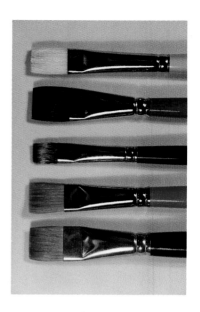

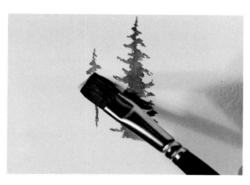

Hold the corner of the bright fairly flat and stamp in the illusion of pine trees. Change the brush angle often for loose, natural-looking boughs.

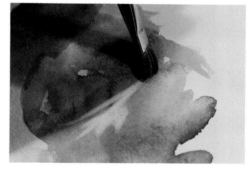

Pulling a wet bright across dried color will remove color in controlled areas. This is a good technique for making soft highlights.

Here a combination synthetic and natural hair bright is used to paint bold dark areas in the rocks with good control. The darkest colors are added last.

Drag the brush flat with a light load of paint to make the rough sides of boards. The shadows from the eaves and cracks are painted next.

Flats

Sable and soft hair flats are more flexible than brights because of the length of hair protruding from the ferrule. This length is usually around 1-1/2 times the width of the ferrule. It is still important that it springs back to its shape even though the hair is quite a bit longer. Delicate blends and soft glazes are possible with the flat-style brush. Its flexibility allows the painter to gently lay one color over another without disturbing or rewetting the undercolor. The flat does not have the sharp corners of the bright when painting because the hairs move so much more. This is not a drawback, as this brush is an indispensable tool for gentle blends and soft manipulations of color. It is superb for wet-in-wet painting techniques, and it will carry a good load of paint to the painting surface

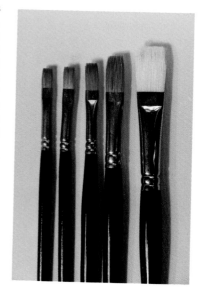

Drawing the brush sideways pulls color up into the sky area for the illusion of distant trees. This stroke is done into a wet background.

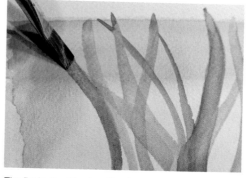

The flat is capable of making long pulls of color such as the grass blades shown here. The flex of the brush allows for good control.

Notice the difference in the flex of the bristles in the flat on the left and the bright on the right. The longer bristles of the flat allow it to bend more.

The flat has greater flex than the bright in this position, also. Each brush has its own characteristics and particular jobs to do.

Watercolor 1" Flat

Specially designed flat shaped bright-style brushes that are used for large washes and massive, quick blocking-in of color are available from a number of manufacturers. And, because of their shape and the strength of their bristles, they are also capable of applying even, graded washes in highly controlled areas. These brushes are the ones chosen most often by the watercolorist and are referred to as the "workhorse." The handles of these brushes have been cut into a chisel shape for use as a tool in painting. When used with care, this chisel end is capable of scraping wet paint away from the paper without causing damage to the surface. It can also be used to texture areas by pressing and patting the paint. Sometimes the flat of the handle can be used to mix a specific color on the palette that may be needed for a wash or some other purpose. The chisel angles vary slightly between makers. These styles are available in red sable and a variety of other natural and synthetic hair, including blends. They are also available in 3/4" and 1/2" sizes.

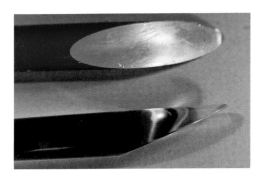

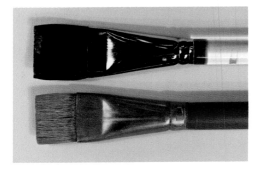

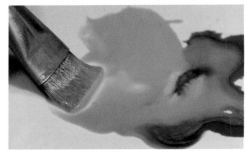

Here, a wet combination synthetic and natural hair 1" flat is used to remove color by pulling it over the area. The ability to remove color is extremely important.

This natural hair 1" flat is capable of holding large loads of color for washes or mixing as shown here.

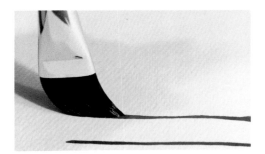

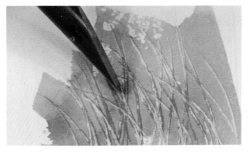

The 1" flat is capable of drawing very thin lines with good control. This synthetic and natural hair blend is excellent for this.

A great amount of textures can be created by dragging the handles of these brushes across wet paint. The illusion of grasses is made here.

Filberts

A filbert-style brush is flat with a curved tip. It is a very important tool because of its unique shape. The filbert is capable of accomplishing many types of strokes. The tip comes to a very fine chisel point which can make extremely fine lines. It can also carry large and small loads of paint to the painting surface, and very fine and delicate blends are possible. The rounded tip allows the brush to be laid onto the painting surface without making harsh start-and-stop marks. This is especially useful when clean water is needed to thin or scrub-out a wash. They are very absorbent and can lift large or minute amounts of color off the painting, depending on how much of the tip is used. Filberts are available in sizes from 1/4" to 1". Some larger specialty sizes are also available.

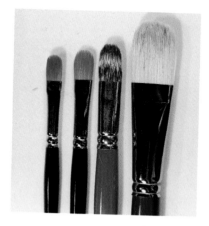

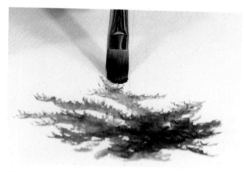

The curve of the filbert can be used to create a number of textures. The feeling of foliage is being painted here. Change angles often.

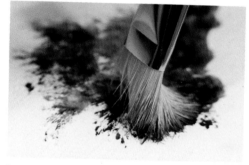

A great amount of splatter and bush textures are possible by pushing and twisting this bristle filbert. The stiffness of this brush helps to create these textures.

Cat's Tongue

This style of brush is called a "cat's tongue" because it resembles the tongue of a cat. Like the filbert, it is a flat-style brush with a curved tip, but it is usually narrower than the filbert. The tip in many of these brushes graduates down to a smaller curved shape than the width would seem to allow. This is due to the way the hairs are set into the brush. Some manufacturers bring the rounded or curved tip of this style of brush to a rather sharp point. This is done so that the brush is capable of a far wider latitude of width spread when the hair is wet with paint. These brushes are usually listed in the tole painting or craft section of a manufacturer's catalog, but they should be considered an important watercolor painting tool for certain special effects. As with any of these flat-style brushes, the cat's tongue will hold a double load of paint, allowing two colors to be painted at once. This is especially important for strokes such as long leaves, blades of grass, tree leaves, and many more.

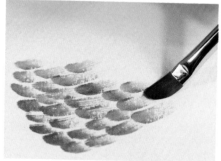

By lightly stamping, dragging and lifting the cat's tongue, we have a stroke that creates a unique look for feathers.

SPECIAL PURPOSE BRUSHES

Script, Liner, Rigging, Signature, Spotting

Script, monogramming, liner, rigging, twiggy, signature, scroll and spotter all basically describe brushes (some blunt-ended, some pointed) that do all of those things or any job requiring fine line control. These brushes are available in natural hair, blends of natural and synthetic hair, synthetic hair, natural bristle, and synthetic bristle. They are valuable tools for ship painters for painting lines and rigging; landscape painters for painting twigs and small branches; portrait painters for painting hair detail; and for lettering in a script style.

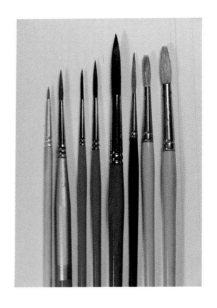

The type and length of the hair or bristle determine what the brush will do. The longer and thinner the hair, the finer the point and resultant line. The shorter the hair, the finer the detail. For a good thick-and-thin line variation, a slightly wider brush is needed. With care, one can obtain the same precise thin line with the point of a larger brush as with a tiny one. It is very convenient to have several sizes. These brushes are available in sizes from 1/16" to 1/4" ferrule width. There are some wider ones available, but these are not usually used for general painting unless large script lettering is needed or the painting is very large.

The sable spotter is good for painting fine lines and signatures. Keep the paint thin for best results.

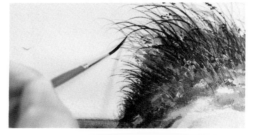

The combination natural and synthetic hair script brush is able to hold a good amount of paint and, therefore, paint long strokes for grasses.

Oval Wash Brushes

The oval wash brush is made of soft hair and is usually labeled either camel or squirrel hair. This hair has less memory for spring-back, but due to the way it is used and the way it is made, brushes of synthetic hair or a blend of both also work well. These brushes are hand-formed to an oval shape and loaded with hair to give a full feeling to the brush. They hold their shapes well when wet and are often used to make feather strokes. The most common sizes are 1/2", 3/4" and 1".

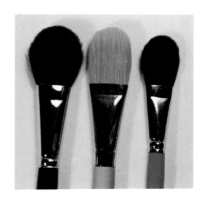

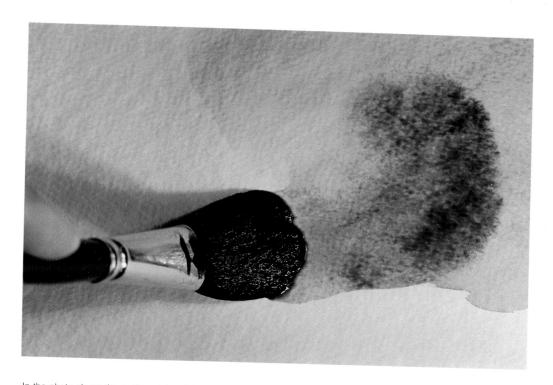

In the photo above the oval wash brush is used to apply color in a pooling manner. This is a good way to carry a large amount of color to an area and then let it settle into the paper for special effects. Notice the amount of color that is still coming from the brush. In the photo below, the same brush is used to apply a fresh color into a wet background. These colors can be manipulated or allowed to run and settle naturally. This type of brush can carry large quantities of paint.

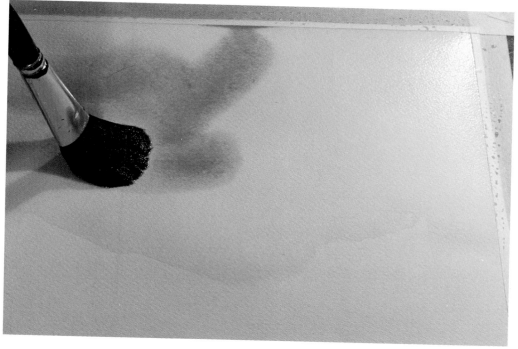

Flat Wash Brushes

There are so many styles and sizes of brushes classified as "wash" brushes that it would be impossible to show them all. I will, however, discuss the most common and frequently used brushes of this classification. A good wash brush can be round, flat, oval, and oval and round in a mop shape, etc. Each manufacturer may change the styling of each one just a bit and give it another name, but they are still wash brushes and are basically used for applying washes in large areas. In some instances, depending on the shape, they are also used for stamping textures and forms onto the paper. Bushes, leaves, boughs, and rough grain texturing for a number of effects are all possible with particular brushes.

Flat wash brushes are made from various types of hair, including both natural and synthetic, and combinations of both. The costs vary depending on the hair and size. The 1", 1-1/2" and 2" are the most common sizes. Some have a tapered square edge that allows the artist to achieve fine lines as well as washes. Where cost is a factor, an inexpensive varnish brush in any size can be purchased through regular paint stores. These work beautifully for large washes.

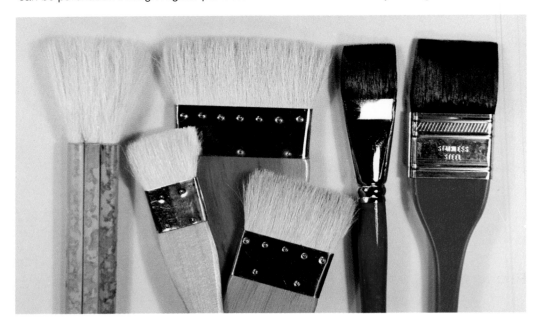

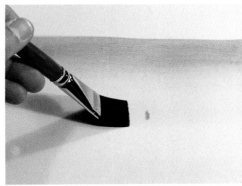

Here, a very delicate blended wash is painted with a brush of synthetic and natural hair. The blend can be abrupt or very gradual.

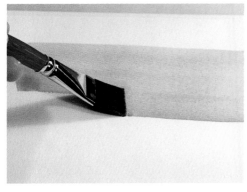

Now the same brush shown at the left is used to paint a very flat wash. Flat washes should be the same value of color overall.

Pressing a slightly damp wash brush onto wet color will "drink" up the color, leaving the paper clean. This is a very useful effect.

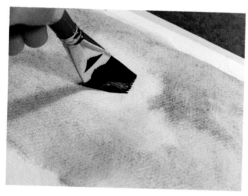

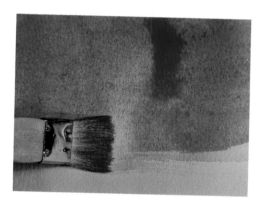

The hake brush is made of very soft natural hair and will hold an ample amount of color. It can be used for large wash areas.

Round Wash Brushes

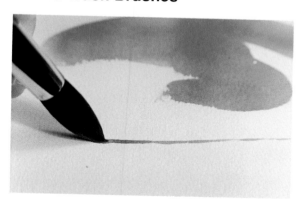

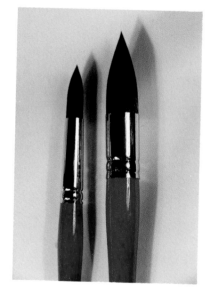

Round wash brushes are available in the same combinations of hair as the other wash brushes. Due to their rounded shape, they are capable of feather strokes as well as soft, fine washes. Their size can be used to stamp the brush sideways, creating another set of textures. Also, thin lines can be drawn using the fine point.

Quill Brushes

There are several styles of brushes on the market called "quill" brushes. These brushes are made of a soft delicate hair and the quill is less destructive to them than the metal ferrule. The quill is either synthetic or taken from ducks, geese, swans and various other birds. These brushes are used for various purposes. The flat-ended brush is popular for lettering, while the fine-pointed brush is great for details and fine lines. Separate handles for quill brushes are available at a very low cost. Sometimes, the handle of another brush will work, too.

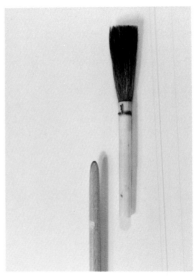

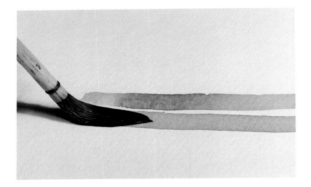

The soft, delicate hair in the quill brush will hold a great amount of paint and produce a long line with a consistent width.

Bamboo/Reed/Oriental Brushes And Pens

These brushes are made from several types of select hair and are shaped to a very fine point. They are used for calligraphy and watercolor painting. With care, extremely fine and long lines are possible with these bamboo and oriental brushes. They hold a good load of paint, yet are still capable of delicate detail. Natural hair is normally used in these brushes. A word of caution: when using oriental brushes, never soak the hair completely as many are set into the handle with water-soluble glue. They are available in various sizes and in a range of prices. The size selected is a personal one since these brushes are made with both very long and very short bristles. There is a tremendous range of width sizes available, also.

Short lengths of bamboo are cut into the shape of a pen on one end and a flattened point on the other. The sharp end is capable of drawing fine lines and the other end works well as a gouging tool to remove paint or to create texture.

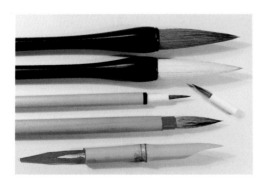

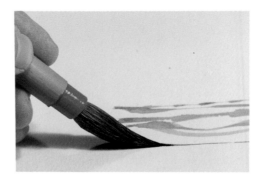

Fan Brushes

Fan brushes are not considered a basic tool for watercolor painters. They are, however, special effects brushes that can be used if done so with care and good taste. These brushes are designed in the shape of a fan, thus spreading the bristles. They are used in oil painting as a blender brush. Some artists use them to paint trees, fur, etc., but because of their shape, these brushes create a monotony of stroke that is very noticeable on the surface of a painting, whether oil or watercolor. They are available in natural and synthetic hair and in a wide range of sizes, from 1/2" to 3-1/2" from various manufacturers.

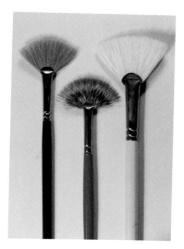

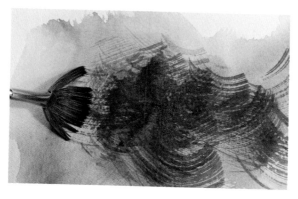

The fan brush is capable of making many textures and strokes. By loading the brush and pulling it over an area with short, sweeping strokes we create the pattern shown here (this is painted wet over dry). With acrylic paint, which is thicker, many other patterns are possible. Try different angled strokes for variety.

Sword Striper Brush

The sword striper brush is used in watercolor to create long, continuous lines. This is not a frequent technique for the average watercolorist, but this brush (which is used more with oils) is a must when lines of this nature do have to be drawn or painted. It is usually made from long squirrel hair and will hold a lot of paint. There are several types on the market and sizes range from 1/4" to 1/2" at the widest part of the ferrule.

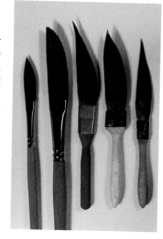

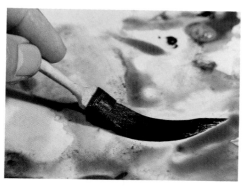

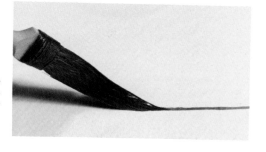

The sword brush is normally used by oil painters, but it can be used with water paints as well. Load the brush abundantly as shown, then set the bristles by pulling it sideways. Use the tip as shown in the second photo to draw a fine line.

CARE AND CLEANING OF BRUSHES

No matter what medium a brush is used with it must be thoroughly cleaned after each use. Watercolor is the easiest medium to remove from the brush, but care must still be taken not to abuse the brush during cleaning. Since watercolor will dissolve even after it has dried, it is not tragic if it accidently dries in a brush. However, never let a brush sit with paint in it, even during a painting session. If this happens, care must be taken to dissolve the paint slowly and not crack the dried paint which might damage the delicate hairs. If not cleaned thoroughly, even watercolor can settle deep in the brush near the ferrule and cause the bristles to spread. This destroys the shape of the brush and sometimes cannot be restored. A repeated caution: when using and cleaning some oriental brushes, care must be taken to soak only about 60 to 75 percent of the hair, as many are set into the handle with water-soluble glues and binders. The following steps are a guide to successful brush cleaning:

1. Rinse the brush in clean water, then use paper towels or a soft cloth to wipe as much paint residue from the brush as possible. Use a gentle squeeze-and-pull motion, and always pull the cloth straight away in line with the bristles, never sideways.

2. Using a very mild soap (liquid or bar), wash the brush in lukewarm running water. (Note — use only cold water when cleaning acrylic! Warm water will set the paint in the brush making it nearly impossible to remove from natural hair brushes.) Even though all of the color was thought to have been removed by rinsing, this procedure will usually remove more. Use a circular scrubbing motion in the palm of your hand, but do not push hard on the brush or you might damage the hairs. A gentle swirling motion is all that is needed.

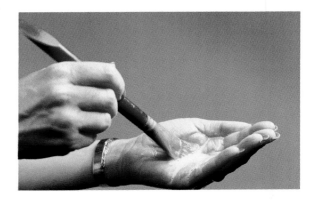

3. It is very important to remove all of the soap residue. Using the same circular motion, scrub the brush in the palm of your hand under tepid running water until all residue is removed.

4. Wipe the brush dry and reform the hair or bristles. Round brushes are reformed easily with the lips, but caution should be observed as contact with paints or soaps might cause an allergic reaction. Once reshaped, the brush should be laid on its side or hung from the handle to dry. Never stand a wet brush on its handle as gravity can contribute to the spread of the bristles and too much moisture at the ferrule might destroy the bonding agent gluing the bristles. Once dried, the brush can be stood on its handle, if necessary.

For longer storage, brushes should be carefully laid in a closed container with a few moth balls added (moths love brushes and can destroy an expensive sable very quickly). Also, make sure the brushes are completely dry so mold or mildew will not develop.

Studio Brush Washers

There are different studio brush washers available for each medium. One that is considered useful for watercolor has a spring on top to hold the handle of the brush, allowing it to hang so the bristles are suspended in water without sitting on the brush end. (If a brush is left sitting on the brush end, the shape of the brush will be destroyed.) Brushes can be suspended in this type of holder without the end touching. An easy one to make at home is one made of metal hair rollers soldered onto two posts that are then soldered to the sides of a can. Different sizes of rollers can be used for different sizes of brushes.

It is not a good idea to leave brushes suspended in water too long (such as overnight) because the excess moisture can loosen the glue in the ferrule and might even cause the painted handle to chip and peel over a period of time. In turn, this loosens the ferrule from the wooden handle. These holders can be a great help when using acrylic paints as the brush can be kept wet at all times. When using acrylics it is a good idea to swish the brush around occasionally to keep the paint fluid.

Brush Cleaners and Preservers

There are a number of brush cleaning and preserving products on the market; they come in liquid, cake and gel forms. Most are directed towards the oil painter, but some are formulated for watercolor and acrylic, too. Some contain chlorinated and petroleum solvents and claim to remove dried oil or acrylic paints from the brush, but acrylic is very difficult, if not downright impossible to remove from the brush once it has dried. Unlike watercolor, acrylic cannot be rewetted after it has dried. Having tried many of these products over the years, I am happy to report that there are several that actually do what they claim. Of course, if a brush is saturated with dried acrylic, only a miracle will remove it and restore it to its original shape. After using these cleaners and restorers it is a good idea to wash the brush in lukewarm water and mild soap to remove any residue that may remain.

The best way to keep a brush in good shape is to care for it as it is being used and to be alert to any sign of built-up paint or medium. With care, a good sable will last many years.

WATER BUCKETS/CONTAINERS

Water buckets are used to hold the fresh water needed to paint and for clearing and cleaning the brushes. It is always wise to have at least two water containers. One should be used for clearing the brush and nothing else. The other one should always be clean and clear and is used for picking up clear water in the brush for mixing colors; this keeps the painting fresh and clean. If the same bucket of water is used for both, it soon becomes dirty and so do the colors. This practice should also be applied to acrylic painting. Glass or clear plastic jars are best so we can see how dirty the water is becoming. Glass is not good for taking into the field; plastic jugs with handles are best for this purpose. You can make two containers for painting in the field by cutting the tops off of two plastic bottles (such as the large soft drink kind). Some painters use plastic for both studio and field painting.

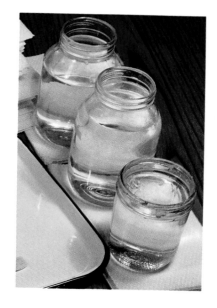

WATERCOLOR PALETTES

There is a great assortment of watercolor palettes available: round, oval, rectangular, square, etc. They can be made of plastic, china, rust-proof metal, or metal covered with a protective coat of paint. Most have a flat area for mixing colors and some have slanted wells that are shallow on one end and deeper on the other, allowing the color to pool. This allows you to pick up large amounts of color for big washes. With these types of palettes color can be squeezed from the tube into the wells. By dipping into the paint wells, color 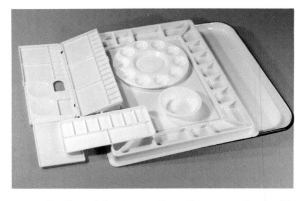 can be mixed with the brush or brought out onto the flat mixing area where they are mixed with water to the desired consistency or color. The mixing areas of some palettes are divided to provide several smaller ones. Aluminum or plastic microwave muffin tins also make good mixing wells. Large amounts of colors can be mixed in these. Compact palette kits that are handy for traveling are also available. These have fold-out trays and several mixing wells.

A white enameled butcher's tray makes a versatile palette. It can be used with watercolor or acrylic paints. The original butcher's trays are no longer produced, but replicas are available through some distributors. Also, similar trays can be found through some medical or restaurant supply houses. I have two of the old styles; one is 19" x 12-3/4", the other is 15-3/4" x 11-1/4". Both sizes are handy and used frequently, especially when I paint with acrylics.

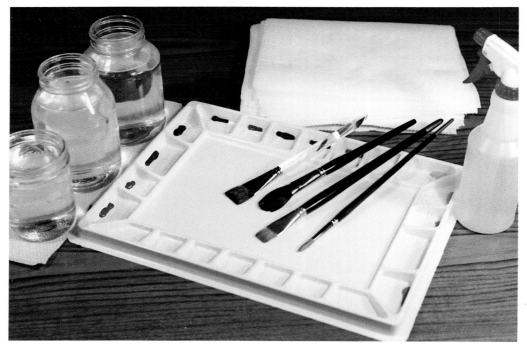

Three jars of water are used for clearing the brushes and mixing watercolors. This will prevent any contamination of fresh colors from dirty water. The tray used here has wells around the sides with a large mixing area in the middle. Large amounts of color can be mixed in this area. Colors are squeezed from the tube into the wells. With a spray bottle to keep the paints wet, paper towels and a few brushes we are ready to go!

PALETTE AND PAINTING KNIVES

Palette Knives

There are basically two types of knives used in painting: the palette knife, which is used for mixing pigments on the palette, and the painting knife, which is used to move paint on the painting surface or, in acrylic and oil techniques, to create an entire painting. Some artists have altered the basic design or have designed knives that suit their particular techniques. These are marketed under the artist's professional name.

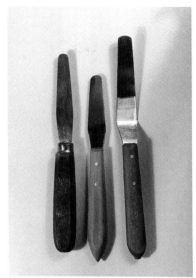

The acrylic painter is likely to employ both of these knife styles more often than a watercolorist. Most watercolors are mixed with the brush while painting and specific, dynamic color combinations are achieved through a series of color glazes. There are times, however, when the watercolorist may need to use a palette or mixing knife. Either knife can be used to scrape paint off of the wet watercolor painting or to create special effects.

These knives are available in two styles: one has a long, flexible, flat blade; the other has a long, flat blade with an elevated handle to assist in keeping the hand out of the paint. Both are slender and have rounded tips. The type with an elevated blade is the most popular. Wooden handles aid in gripping the knife. When mixing paint, these knives are designed to be used in a kneading stroke, not a stirring motion. Care must be taken not to overmix any color.

Painting Knives

Painting knives can be used to create extremely fine works of art. They are made in many shapes, sizes and styles. Again, some artists have altered them to create a personalized knife. A good painting knife must be thin, flexible and sensitive to the touch. The blades are made of hand-tempered steel and are usually all one piece, but sometimes they are soldered or welded to a long, thin handle. These knives can be used with watercolor to push paint around, such as on rock surfaces. With acrylic they can be used to create complete paintings similar to oil techniques. They can also be used to create textures.

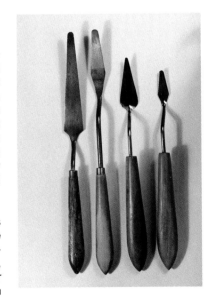

In my opinion, the most versatile style of painting knife is the tear-shaped knife with a small rounded tip. These have no sharp angles to accidently dig into the paint surface and damage the paper. The more the knife is used, the more flexible it becomes. The edges become razor sharp after long periods of use, so wipe older knives with care.

Any painting knife must be flexible toward the tip for manipulation of paint in small areas. No matter which type of knife is used, palette or painting, in today's terminology this use is always referred to as a "palette knife painting."

WATERCOLOR PAINTS (Ready-To-Use)

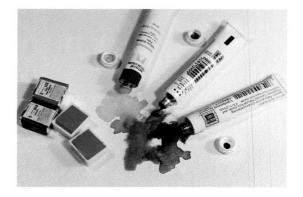

Watercolor paints are made of finely ground pigments suspended in a water-soluble binder. This binder (gum arabic) is not only important in holding the pigments in solution, but also for attaching and clinging to the painting surface. Since watercolor is usually painted on in such thin layers of color, it is important to have enough gum arabic binding power to adhere to the paper. Other ingredients such as glycerin for moisture, wetting agents for color flow, and preservers to inhibit mold are also added.

Unlike oil or acrylic, watercolor can be manipulated after it has dried simply by rewetting it. Therefore, the final painting must be properly framed and protected from moisture. One good way is to matte the painting, then wrap it in plastic until it can be framed permanently.

Tubes, Pans and Cakes

Watercolor is available in several different forms. The most popular is tubes. These tube sizes range from 15 ml to 5 ml. The 5 ml size is the most popular among students and for painting on location. Tubes are available in kits or individual colors.

Colors are also available in individual "pans." These are shallow metal or plastic containers (depending on the maker) with paint in them. They contain the same type of paint as the tubes, except it has been placed into the pans and allowed to dry. These colors do not dry completely hard while in the pans due to the addition of glycerine. This keeps the color rewettable until used. It is a little more difficult to obtain a large amount of paint from them quickly. It is easier to squeeze color from the tube and just add water when large amounts are needed. I like to take both kinds into the field with me.

Watercolor is also available in crayon, pencil and little blocks referred to as "cakes." Tubes and pans are the most popular forms.

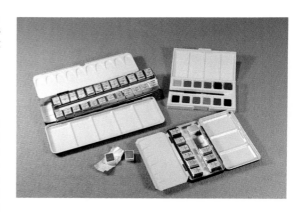

Kits

Pan colors are also available in kits. They come with a folding box-type palette that holds removable pans of dry color. They usually have several flat areas and several welled areas for color mixing. Some open like a book, creating two working areas; some open more conveniently into three sections. The trays of pans are removable in some designs, creating a deeper area for larger wash mixing. The individual pans of color may be arranged for special field trips and replaced when depleted. Note — these are not the inexpensive boxes of paints we used as children; they are designed for use by artists. They come with either artist's quality paint or student grade paint. The student grade is not inferior paint; it is simply less expensive due to the ingredients and packaging. It is still suitable for use by professionals.

COLORS

There are no hard and fast rules written into industry paint standards for color variations for the same named color, but there are guidelines as to the ingredients used and the general tinting strength of the colors.

Color variation and mixing is a bit more confusing with oils than with watercolor. With watercolor, we use the pigment in a pure state; we do not weaken it by mixing it with white or opaque colors. An opaque white, known as Chinese white, is used occasionally, but mostly for bringing out highlights or for special effects such as a splatter for snow to give the painting the illusion of more depth. It is almost never mixed with the watercolors; doing so would destroy the transparent beauty of each color and the painting would become chalky and lifeless. By mixing white into the colors, we are also changing the pigment from pure watercolor to gouache — an opaque watercolor paint. When opaque white is introduced into a watercolor painting, the painting is no longer considered a true, pure transparent watercolor work.

Most manufacturers produce several lines of paint and the colors will vary slightly from line to line. There are several colors that cannot be mixed by the artist using the three primaries of red, blue and yellow. This is due to the ingredients used in making the specific color. In those cases, we must simply purchase the color (but it is best to begin with a small range of colors). A simple selection of reds, yellows, and blues are all we need to begin with. The following is a list of commonly used colors that most manufacturers offer:

Alizarin Crimson	Lamp Black
Brown Madder	Lemon Yellow
Brown Madder Alizarin	Light Oxide Red
Burnt Sienna	Manganese Blue
Burnt Umber	Mauve
Cadmium Lemon	Naples Yellow
Cadmium Orange	Neutral Tint
Cadmium Red Deep	Olive Green
Cadmium Red Light	Paynes Grey
Cadmium Yellow	Permanent Green Light
Cadmium Yellow Deep	Prussian Blue
Cadmium Yellow Light	Purple Madder Alizarin
Carmine	Raw Sienna
Cerulean Blue	Raw Umber
Cerulean Blue (Pthalocyanine)	Rose Madder
Charcoal Grey	Sap Green
Chinese White	Sepia
Cobalt Blue	Terre-Verte
Cobalt Green	Transparent Oxide Brown
Cobalt Violet	Ultramarine Blue Deep
French Ultramarine Blue	Ultramarine Blue Light
Gamboge	Van Dyke Brown
Hookers Green Deep	Viridian (Green)
Hookers Green Light	Vermillion
Indian Red	Violet
Indian Yellow	Yellow Ochre
Indigo	Yellowish Green
Ivory Black	

In addition to this list, each company makes colors that are labeled with their own names which are referred to as "house" names or "proprietary" names. Good examples of these are the colors derived from copper pthalocyanine.

Quality

Watercolor paints vary in quality. It is best to purchase paint manufactured by a proven maker because you are less apt to go wrong. There are a number of paint manufacturers that are not big, yet their product is as high in quality as the large companies. A person must do some research to discover exactly which products are good and which ones are not; price is not always an accurate guideline.

Normally, the best paints made from the purest ingredients are labeled "artist's" and the lesser paints are labeled "student." This does not mean that paints labeled "student" are not good, they are just made from less costly ingredients and pigments, and, therefore, are a more economical line. It is always best to buy the finest materials affordable. With watercolor, it is good to know the maker since the paint is used in its purest state and will be viewed against a white background. Any flaws in quality will be seen immediately.

Blacks

Blacks are used to mute or shade a color. They are considered the absence of light, and, there-fore, the absence of color. This means that they will take away the richness and chromatic bril-liance from a color when mixed with it. The use of blacks can be very destructive and create muddy effects if not thought out properly. Any color can be subdued more naturally by adding a touch of its complement to it (see *Color And How To Use It* in Walter Foster's Artist's Library Series). Blacks can, however, be used to reach deep, dark tonal effects, when desired. Another way to consider blacks is to think of them as mixing pigments. For example, when black is mixed with yellow, a deep-toned, muted green is the result; when mixed with some red colors, the result is purple.

Whites

Whites are rarely used in the art of pure watercolor painting. At one time, an artist was frowned upon if there was white present in his or her palette. Today, it is being used more widely for special effects as described earlier, but is still not accepted in some circles and associations. It should not be mixed with other colors as it is in other painting techniques because it will destroy the brilliance of the color.

In mixing, white is thought of as white light. White light is the source of all color, and if the light is turned up too brightly, the colors become washed-out and hard to see. The light acts as a glare. This same wash-out of color takes place if we add too much white to our color, the colors become pale and weak. If we do not mix white pigment into our watercolor, but still lay down a weak wash of color, the white of the paper overpowers the color and the colors appear pale.

Permanence/Lightfastness

The permanence of a color is a prime concern for all painting media. With watercolor it is extremely important to be aware of the permanence and lightfastness of each color used because they are laid down in such thin washes and layers. Lightfastness refers to whether or not the color will fade when exposed to sunlight or other harmful lights such as fluorescent. If a color does not fade it is considered lightfast; if it fades within a short period, it is considered "fugitive." Each manufacturer has its own set of symbols that indicate the permanence of a color by how lightfast it is. Some use a system that is broken down into four categories; others use three. Symbols range from plus marks to asterisks to letters of the alphabet. As an example, four plus marks (++++) would mean extremely lightfast and permanent; three plus marks (+++) would mean fairly permanent and light-fast; two plus marks (++) would indicate that the color is only moderately lightfast; one plus mark (+) would mean the color is fugitive and not very lightfast.

For a painting that will last for a great number of years, avoid using any of the colors considered fugitive. It is of no harm to use them for commercial work and work that is intended only for the camera and/or reproduction and will then be destroyed. There are usually enough colors within better lightfast ratings to create the desired image anyway. Also, colors will fade faster when used in thin glazes than when used in mass.

Transparent/Semi-transparent/Opaque Colors

Oil, acrylic and other opaque paints are rated as to transparency or opacity by symbols showing how much of a square is covered. Watercolor charts and tubes do not have these ratings since they are all considered transparent. There are some colors, however, that are not as transparent as others. These will lay down differently in a glaze; some even settle into the cavities of the paper leaving a sediment. Run some tests with your colors on rough paper and note which colors settle or "pool" and which ones leave a residue. Since there is no chart rating to use as a guide, a common practice is to make one yourself. By drawing a thick black line of permanent ink as shown below, you can paint over it with each color and see how transparent it is. Then make another chart to see how each color will look when it is painted over the other ones. Paint a set of color strips. Once dry, paint another set of color strips across these and note how each color appears. A color that is not quite as transparent can impart a soft over-effect to an under color. This chart will help show what is possible with each color. Make a number of charts; they are great for reference.

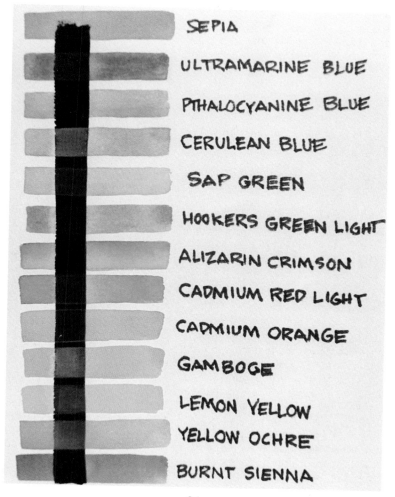

SEPIA

ULTRAMARINE BLUE

PTHALOCYANINE BLUE

CERULEAN BLUE

SAP GREEN

HOOKERS GREEN LIGHT

ALIZARIN CRIMSON

CADMIUM RED LIGHT

CADMIUM ORANGE

GAMBOGE

LEMON YELLOW

YELLOW OCHRE

BURNT SIENNA

Staining/Nonstaining Colors

There are a number of colors that are considered "staining" colors. These colors are usually made from dyes and are commonly the most transparent colors. Staining ability can be a benefit or a problem. Once we are familiar with each color and whether it is permanent, transparent, etc., we must also be aware of its staining quality. A staining color will not only stain the painting surface and cannot be removed, but will affect all other colors it is mixed with. There are strong staining colors and others that stain, but not quite as much. The best way to discover which colors are staining and which are not is to see them work. Apply a small swatch of color to a piece of watercolor paper and let it sit for a few seconds. Then, using clean, clear water, try to rinse the color away. The less it washes away, the stronger its staining power; the easier it is removed the less staining power it has. Some colors have no staining power; they will not soak into the paper or make a permanent stain at all.

If used as a glaze, a color with a strong staining power will stain all the dry colors it is painted over. This can create one color mass instead of a lively layer of glazes. For this reason, staining colors are often laid down first.

The more charts and experimental exercises you do, the more acquainted you will become with each color. Start with a few and add as you go. It's fun to see the different effects possible with this wonderful medium.

Here, alizarin crimson (a staining color) endures even while a wet sponge is used to try to remove it. It is impossible to remove all traces of a staining color. The color can certainly be lightened a bit with a wet sponge or brush, but it cannot be completely removed. Alizarin crimson is considered to be a strong staining color; this should be kept in mind when using it. With careful planning we can turn this staining ability to our advantage. For instance, an underpainting of soft alizarin crimson on flower petals can then be affected by any of the other colors painted over it.

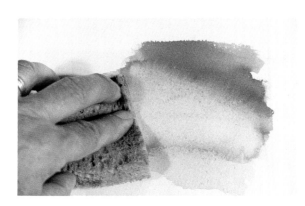

Here we see that ultramarine blue can be completely wiped away using the same sponge as before. This tells us that ultramarine blue is not a staining color. It can be wiped off in a manner that leaves a clean line at the edge of the wiped area. This is important for control of color masses next to clean areas.

Colors are either staining, nonstaining, or slightly staining. Some colors that are considered to be staining are: alizarin crimson, hookers green, pthalocyanine blue, pthalocyanine green, aureolin yellow, new gamboge, sap green, and cadmium yellow medium. Some of the colors that are considered to be nonstaining are: ultramarine blue, cobalt blue, burnt sienna, yellow ochre, raw umber, rose madder genuine, and viridian green. There are a few that are considered light staining colors; cadmium orange is one. Test some of the other colors not listed and make notes as to how much staining power each one has.

Staining power is also affected by how much sizing the paper contains. The more sizing, the less penetration of color and, therefore, the lighter the stain.

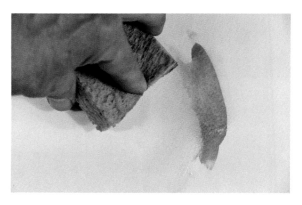

Dry Pigments

Paint pigments in powder form are available for those who wish to experiment and make their own colors. It is easier to work with pigments when making oil paints due to the opacity of many of the oil paints. With watercolor, however, we must be absolutely sure that the colors are ground extremely fine and suspended in the binder evenly. It is exciting and very interesting to originate colors from dry pigments. They are available in sev-

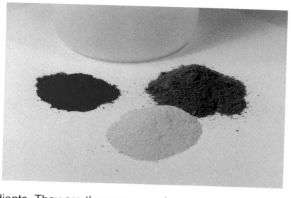

eral grades and are made of the finest ingredients. They are the same powders manufacturers use in their paints. Many producers will not guarantee that the colors will match the colors on their ready-to-use paint charts. This is understandable due to their lack of control as to how the pigments will be used in individual studios. When added to binders and wetted, some of these powders will darken. This darker color is close to the appearance of the final color when dried. When ordering, make sure the powder is ground finely enough to be used for watercolor.

A very simple method of creating paint is to mix dry powder with commercially prepared gum arabic solution discussed in the section on watercolor painting mediums (see page 34). The gum arabic solution must be smooth, even, and not too runny. You can mix a color and use it fresh, or pour it into little receptacles to dry. By using the dry method you are making "pans" of your own. Great care must be taken to obtain the right consistency; the only way to accomplish this is to experiment. Dry powder pigments are available in jars and cans from two fluid ounces up.

WATERCOLOR MEDIUMS

Pure Distilled Water

The most common medium used with watercolor is, of course, water. It is the thinning and wetting agent for the paints. But, with all the chemicals and additives present in tap water, it is a good idea to use distilled water with paints whenever possible. Many painters scoff at this and say that the chemicals are so minimal that any film or residue present will never be noticed by the viewer. This may be true, but if there is completely pure water available with no impurities to attack the pigments or cast a film, I feel that it is wise to use it. Not only does it help the colors to remain clear, but it is clean and contains nothing that will cause the pigments to be acted upon in time, thereby ruining the lasting quality of the painting.

Ox Gall

Ox gall is derived from the gallbladders of oxen. It is a pale-colored, odorless liquid that is added to watercolor to aid in the flow of paint. It is a wetting agent and it also assists the paint in adhering to the paper when very thin washes are used. It is available in bottles from one-half to one fluid ounce. Larger amounts can be special ordered. It is not expensive for the job it performs.

Modern Wetting Agents

There are a number of modern wetting agents that are beginning to replace ox gall. They function just as well and in the same manner as ox gall. In some cases they are considerably less expensive. These wetting agents are packaged in bottles from one to two fluid ounces.

Gum Water

Gum water is a natural gum mixed with water, preservers and essential oils. It is used as a binder for watercolor and increases the transparency of color. It is a pale-colored solution and is available in bottles of one and two fluid ounces. There are a number of these gum water solutions available and some are acidified. Care should be taken to make certain that if using one of the acidified solutions, no acid-sensitive pigments such as ultramarine are used with them.

Gum Arabic

Gum arabic is the primary binder used in the making of watercolor. The type available is a combination of gum arabic, preservatives and water. It can be added to watercolor to increase the gloss and transparency of a color. It is also helpful in strengthening the bonding quality of the color to paper when used in thin glazes. For those who wish to experiment and make some of their own colors, this would act as a quick, ready-to-use binder ingredient.

Natural Gum And Water Paste

A creamy paste of natural gum and water gives body to colors that have been thinned to a fine glaze. Washes are not as fluid with this paste — it allows the artist to apply a very wet wash without the runs that occur with just water, and it is useful for preventing the edges of washes from spreading into unwanted areas. Caution — a buildup of this paste may cause the loss of the thin, pure watercolor look.

WATERCOLOR PAINTING SURFACES

Watercolor Papers

There are a number of surfaces to which watercolor will adhere, but the best results are achieved when fine quality watercolor papers are used. These papers are called 100% rag papers, but they are not really made of rags. They are made of a pulpy mass that contains linty fibers of linen, cotton, or both. Pure linen papers are extremely difficult to find as very few of them exist on the market today. There are, however, papers that contain varying degrees of linen along with cotton.

Papers are available from handmade, mould-made, or machine-made sources. Handmade papers are made one sheet at a time. This creates a paper with a non-uniform texture. Most watercolorists prefer a paper with a rough texture that is not uniform and does not have the monotony often created by machines. Note — sedimentary colors might settle in the low areas of the rough paper. If this happens, a second brushing while wet will even out the color. Mould-made papers are made by machine, but the sheets are formed one at a time. Machine-made are made in rolls and cut to size. They are the least expensive; handmade are the most expensive. All three are excellent papers, but handmade is often desired because of the grain or texture. With machine papers, the slurry or pulp will sometimes develop a one-directional texture from the movement of the machine and screen onto which it is poured. With handmade paper, the pulp is gathered by hand by dipping the screen into the vat and rocking it in different directions to control the evenness of the paper. Handmade papers usually have a water mark that identifies the maker.

These fine papers are acid-free and should not contain anything that might attack the paint ingredients or cause the paper to yellow or become brittle with age. They have been treated with alkaline to help the paper remain acid-free as it ages. This is very important since watercolor paintings are based on the brilliance of the white of the paper. If this should yellow, the whole painting would take on a completely different cast and the work would be destroyed.

Sizing

The finest watercolor papers are treated with a sizing of gelatin or hide glues to control the absorbency of the paper. If a paper is untreated it acts as a blotter and no color control is possible. Or, if a paper contains too much sizing, the color will sit on top of or roll off the paper, creating the opposite problem. To prevent these problems, paper manufacturers control the sizing of each sheet very carefully. Sizing is a very important part of paper making. Paper that has received an excess amount of water or has remained wet too long will sometimes lose its sizing. The sizing can be replaced with a weak application of gelatin or hide glue mixed with water. The paper is treated by dipping it into the weak gelatin solution, which should always be kept as thin as possible. A 3/4 teaspoon of gelatin to 1/2 gallon of water will usually make a usable, mild solution. Care must be taken to keep it weak and not overdo, or it can seal the paper and create absorption problems for continued paint applications. It is best to experiment with a small scrap of paper first.

Weights of Paper

Paper is categorized by weight, size, and surface texture. We will consider the weight of the paper first. The lighter the paper, the more it will tend to buckle or wrinkle when wet. This presents a problem when manipulating several wet glazes. For this reason, a paper of substantial weight is recommended. Some companies now offer a paper lighter than 100 lbs. that is advertised as "non-buckling." The lighter the weight reference number, the thinner the paper. These weights refer to how much 500 sheets of paper weigh, not each sheet. The paper size has something to do with it, also, since 500 larger sheets of the same paper would, of course, weigh more.

There are so many different sizes of papers offered that it would be impractical to list them all here, but there are some general guidelines that will help. For instance, a ream of paper (500 sheets) is weighed and this is the weight assigned to each sheet of that ream. Since sizes vary so much, a standard size of 22" x 30" is usually used for determining weight . Reams with larger or smaller sheets are assigned the weight they would be if they were 22" x 30". When buying odd sizes, the actual weight can vary, but when buying the standard size, you can be assured of getting paper that is very close to the weight it is labeled. Generally, weights range from 72 lbs. to 300 lbs., with some papers reaching 400 lbs. Any papers less than 200 lbs. should be stretched to keep them from wrinkling. The papers of 200 lb. and 300 lb. weights are very stiff and board-like and, depending on the painting technique used, may not need to be stretched prior to painting.

It is most economical to buy watercolor paper in 22" x 30" full sheets. You can cut them down to 15" x 22" half sheets or 11" x 15" quarter sheets, if needed.The best all-purpose weight to use for field trips, in my opinion, is 140 to 180 lbs. They are easily handled, cut and carried into the field for sketching. The heavier 300 to 400 lb. weights are wonderful for a major work and would be wasted if cut and used for sketching trips, practice, class work, etc.

Shapes and Sizes

Watercolor paper comes in individual sheets, pads, blocks, and rolls. These range from 6" x 9" pads and blocks to sheets of various sizes, and rolls of 48" x 10 yards long. Some companies offer rolls of larger widths and up to 100 yards long. Blocks vary in size with the common range being from 7" x 10" to 19" x 24", with a variety of sizes in between. These blocks consist of sheets of paper of various weights (90 to 140 lb. average) that have been cut to a certain size, attached to a stiff cardboard backing, pressed tightly, and glued all around the four sides. The glue prevents water from seeping between the sheets when the top one is being used. As a sheet is used, it is pulled away, exposing another clean sheet ready for use. The only problem is that a sheet of lightweight paper in block form cannot be stretched and, therefore, may wrinkle a bit. The advantages of using a block on a field trip, in painting classes, or any other time you need a number of equally sized and weighted sheets far outweigh the problem of a few wrinkles.

Watercolor paper is also available in stiff board form. The paper is attached to an acid-free illustration board and is available in a variety of sizes. Paper in board form is handy since it does not have to be stretched and is tougher than the individual sheets. It is more difficult to cut, but with a good mat knife and a metal straight edge, it is no problem.

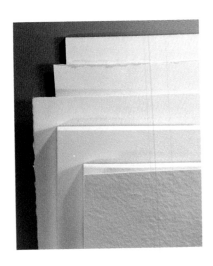

The papers shown from top to bottom are: cold-pressed paper mounted in illustration board form; 140 lb. paper cut from a roll; a single-sheet of 300 lb. paper; paper in watercolor block form; loose sheet 140 lb. paper in pad form, glued only at the top. All are excellent; each one has its own convenience.

Surface Textures

The next qualities of watercolor paper to consider are the different surface textures. "Non-pressed" has an extra rough-grained surface; "rough" has a bold-grained surface that is not quite as textured as non-pressed; "cold-pressed" has a nice surface texture, but is not as coarse as the previous two; "hot-pressed" is a smooth paper with just a slight grain; and "plate finish" has a very smooth surface with no grain at all. Plate finish is not used for watercolor very often because watercolor performs better when applied to a paper with a grain and some absorbency. Colors that are applied to plate finish paper appear less rich than when painted on the more textured papers.

In order to obtain the various textures, the paper is treated several different ways. The pulp or slurry is gathered onto a wire screen that is attached to a wooden frame (called a "deckle"). Some of the pulp runs under this frame in the gathering process and creates an uneven, "deckle" edge to the paper. The paper pulp is then transferred to various surfaces that will create the desired texture, then pressed and dried. The sheets are either left with the rough deckle edge or trimmed and put into pad or block forms.

For rough finish, the sheets are pressed and dried between layers of felt or some other surface that will produce the desired rough texture. Cold-pressed (less rough) paper is stacked and pressed against one another before it is completely dry in the previous stage. By pressing against one another, each sheet presses the rough texture into the sheet next to it. This maintains a grain, but is smoother than "rough." For the hot-pressed finish, the paper is run between steel rollers at varying pressures. These rollers press the paper into a smooth surface with just a small amount of fine grain left. This grain can vary slightly from maker to maker. The smoothest finish of all, plate finish, is set between polished steel plates and then run through pressurized rollers to gain an extremely smooth finish. This smooth paper is used only for special presentations of watercolor painting.

The textures from top to bottom are: rough finish, cold-pressed, hot-pressed, and plate finish. Plate finish is the smoothest; it is not used very often for watercolor.

The papers described here are the best surfaces for watercolor painting, but don't be afraid to try other surfaces and textures.

MOUNTING AND STRETCHING WATERCOLOR PAPER

Heavyweight paper such as 300 lb. can be attached to the drawing board dry. Masking tape, gummed tape, staples or thumbtacks can be used to secure it. The paper can be painted on without fear of buckling; no stretching or shrinking methods need to be used.

Papers of lighter weight (usually less than 140 lbs.) will wrinkle and ripple in an uneven manner when wetted, so they must be stretched out flat and shrunk before applying paint. Wrinkles will prevent the brush load of paint from gliding evenly over the surface which can be a real problem when applying washes. Also, color settles in the lower points making control impossible.

There are several ways to stretch paper to prevent rippling or buckling. The easiest and most often used is the wet taping method. Using a sponge or large paint brush, dampen the paper thoroughly on both sides. Take care not to oversoak; if it is too wet it may tear during the drying/shrinking process. Test the paper by flicking a corner with your finger. If it is limber and does not snap back, it is the proper wetness; if the corner droops and bends down from its own weight, it is too wet. The paper should have some life left in it and not be completely limp. Some artists soak the paper in trays, but caution should be taken not to oversoak and remove or weaken the sizing. Next, lay the paper out on a drawing board that has been varnished to prevent water absorption or a similar board that is perfectly flat with no surface imperfections, and gently press it out flat with a large sponge. This sets the paper and removes excess water, allowing for more even evaporation and drying. Use a dabbing or pressing motion with the sponge rather than rubbing. Rubbing saturated paper can cause surface scars that might show when color is applied. Tape the paper down on all four edges with 2" gummed tape, such as packing tape. The tape should hold the paper tightly, then as the paper dries, the shrinking of the paper will cause it to become firm, taut, and flat. The paper will remain flat throughout the painting process.

Another method is to staple the damp paper to the surface. If this process is used, a small gasket-like wad of paper should be placed under the staple to keep the sharp edges of the staple from damaging the paper or causing tearing during drying. Staples should be close enough together to prevent sagging or uneven shrinking patterns. Not only does the staple method punch holes in the paper, but it creates holes in the support board which destroys its surface and can cause future problems. In my opinion, the taping method is the easiest one, as well as the best.

There are several products on the market designed to make paper stretching easier. They consist of boards and frames that allow the artist to lay the paper out without using tape or staples. Frames are attached to the board, holding the paper taut.

After soaking the watercolor paper with a sponge or in a tray, test a corner with your finger as shown at the right. The paper should have life, but it should not snap back too quickly. If it does, it is not wet enough. Care should be taken, however, not to oversoak and wash the sizing away. Each weight and brand of paper will absorb water differently, so it is wise to run a test on a small piece first. This will give us an idea of just how long to soak the large piece

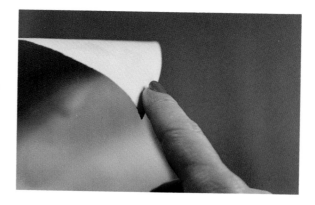

STEP 1. Gently lay the paper on the board and press it onto the surface with a wet sponge. This not only helps the paper to cling to the board, but eliminates large wrinkles that may occur while laying the paper in place. Try not to scrape the surface with the sponge (or any other object for that matter) as this might cause slight surface mars to show up in the painting.

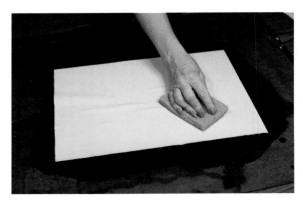

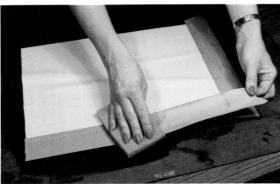

STEP 2. Using two inch paper tape and a wet sponge, press the tape into place and gently wipe with the sponge. The tape should overlap the paper just slightly. Some artists prefer an overlap of one inch, but I overlap mine between one-quarter and one-half inch.

STEP 3. Before pressing the third piece of tape down, use the sponge to press out any wrinkles that might have developed during the previous steps. The paper will stretch a little when wet and shrink as it dries. This step also insures that the paper is uniformly wet throughout the taping process.

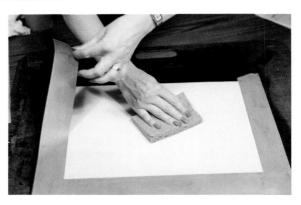

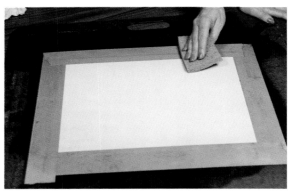

STEP 4. The final step is to apply the tape to the remaining sides. Make sure the tape is uniformly attached to the paper. Once the paper is taped in place, set it aside to dry. It is better to lay it flat so the paper will dry evenly. As the paper dries, it shrinks and forms a tight, flat painting surface.

As shown in the photo, watercolor paper can easily be attached to a board or flat surface by using simple masking tape. The only problem with masking tape is that we must be careful as to how much water we use to shrink the paper. Since the tape must be applied to dry paper in order to hold, the water for shrinking the paper must be applied after the paper is in place and taped. A few quick passes with a thoroughly soaked sponge will do the trick. Then, once the paper begins to wrinkle, the excess water can be picked up and the paper allowed to dry.

Wet paper can also be attached to a soft board surface with a staple gun. By placing a soaked piece of paper on the board and quickly stapling it down, we can be assured of a flat, smooth painting surface when the paper dries. When using staples more than once on a board, care must be taken to make sure the paper is never placed over any of the bumpy holes left by the previous staples. These bumps will be a continuing problem if overlooked.

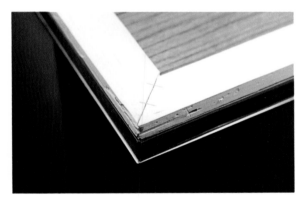

Watercolor paper of various weights can be stretched onto the same type of small wooden stretcher bars that canvas is for oil painting. This provides a flat surface with nothing rigid behind it. Some painters like the flexible, "drum" feeling of paper that is stretched in this manner. Note — stretcher bars must first be "squared." An easy way to do this at home is to use the corner of a desk or table as a guide. Once squared, staples can be used to secure them.

Place the paper onto the bars and start stapling from the center of each side towards the corners. Once the corners are reached, the paper can be folded as shown and the final staple placed. It should be set aside until the paper is dry. This method works best with fairly heavyweight paper.

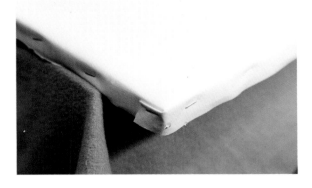

MISCELLANEOUS EQUIPMENT

Drawing Boards, Easels and Boxes

There are various types of drawing boards and easels available for watercolor and acrylic painters. The watercolor easel is extremely lightweight and collapsible so it can be taken into the field or used in the studio. It will hold a drawing board or canvas and the surface can be tilted or adjusted to an upright position. All in all, it is a very versatile easel. There are also larger, more massive easels that can be used in the studio (see *Oil Painting Materials And Their Uses* in Walter Foster's Artist's Library Series). The choice is a personal one.

Drawing boards should be very smooth so they will not interfere with the laying down of wet watercolor paper. They can be made from a number of types of wood. One can be made from a very smooth plywood or paneling in a pinch. Care must be taken to make sure that the chosen wood is perfectly smooth, as ripples might affect the flow of color on thin papers or the way that any paper will stretch over the board.

Some drawing boards are made of plastic. These have an extremely smooth surface that is a pleasure to work on, but they are heavier than wooden boards. The surface of natural wood boards are more comfortable for some; they are preferred by most of the painters I know.

Brush boxes come in so many styles that it is impossible to show them all here, so I will describe them generally. Simply stated, they are boxes made of wood, plastic or metal that are, in most cases, similar to fishing or tool boxes.They are designed to carry paints, painting supplies, and brushes in one convenient container.

There are also boxes designed for brushes only. These are helpful for keeping clean brushes away from moths and from banging into each other. There are little holders for each brush which keep them from sliding and allowing the brush tips to be pressed against the end of the box, causing them to lose their shape.

WATERCOLOR SUMMARY

Watercolor is a very exciting medium. It allows for a variety of subjects and the rich colors and delicate transparencies obtainable are unique and beautiful. Transparent glazes applied over one another result in a particular richness that immediately identifies the work as a watercolor. Of course, any manipulation of technique will mean the viewer must study the painting very carefully to make sure it is a watercolor. This versatility is one of the exciting things about painting in watercolor. One can be loose and free, or tight and technical to the photo-realistic degree. This is simply a matter of technique of application, craftsmanship and draftsmanship.

Most of the tools and materials shown and discussed in the preceding watercolor pages can be used with acrylics. These two media are water-soluble paints and, in this way, are very similar. However, watercolor is transparent, and acrylic can be painted either transparently or opaquely (similar to oil paints). Both are wonderful mediums, but acrylic has a broader range of technique applications.

All of the surfaces used in watercolor painting can be used for acrylic painting, but the same cannot be said in reverse. These two mediums can be combined to create a mixed media painting. Do a few experiments using both and I'll bet that you will find the results intriguing and fun!

INTRODUCTION TO ACRYLICS

Acrylic (polymer) colors are synthetic (man-made) paints. They are an extremely versatile medium to work with because they can be painted thickly as with oil paints, applied in thin watercolor-type washes, or used to mimic the details of egg tempera, or combined with other media for a variety of effects and techniques.

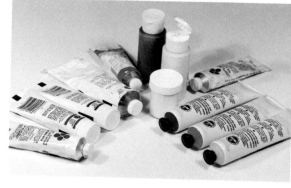

Acrylic can also be used as an undercoat for oil paints, but it cannot be applied over them. Acrylic will adhere to just about any surface that is slightly absorbent or porous, but it will not adhere permanently to any surface that contains even the slightest amount of oil or wax.

Acrylic is very flexible and may be painted on stretched fabric surfaces, primed or unprimed, such as canvas. It can also be used on acrylic-primed boards or panels and any number of stretched or unstretched watercolor paper surfaces.

The binder for acrylics is a wet acrylic resin emulsion that can be thinned with water. This "plastic" paint also uses water for its primary thinning and painting medium. Some colors are transparent, thus allowing the artist to use them in watercolor techniques, and some are opaque. Also, these paints allow the artist to apply many layers of thin, delicate glazes over one another to obtain depth or gradual tonal shadings. In this instance, as with watercolor, the white of the paper becomes the lights of the painting and no white paint is used. For techniques similar to those used with oil paints, acrylic titanium white is used. It is very brilliant and creates beautiful tints when mixed with other acrylic colors.

Most acrylic paints dry very quickly and this characteristic frustrates some artists who are used to having time to manipulate slow-drying oil paint until the desired effect is achieved. But this medium just needs to be approached a little differently than oil. There are some acrylics on the market that have a slightly longer drying time than others.

Each manufacturer has their own complex formula for their paints. These formulas may vary in color, drying times, viscosity, opacity, and ingredient condensation. Because of these factors, I do not mix brands without first performing tests to insure that they are compatible. Since acrylics dry quickly, these tests take very little time. Fine paints from well-known, reputable makers are permanent, and if the pigments intermix well and dry without negative results, the work can be considered permanent.

Rather than trying to establish long procedures of color blends with fast-drying acrylics, it is better to make numerous applications of transparent glazes. The more thoroughly and thoughtfully the artist plans and executes these glazes, the more depth and brilliance the resulting color will be. Notice the color changes in this photo.

Acrylic paints are generally considered non-toxic. Some people who are allergic or affected by the strong fumes and solvents used in oil painting have tried acrylics with great success. Also, no health hazards exist with the main thinning solution since it is only water.

Due to the quick drying characteristic of acrylics, there are good and bad results reported from taking them on outdoor field trips. The weather makes them dry faster, but, on the other hand, this is good for applying a number of color glazes on the spot and then stacking the work for transport back to the studio. Because of the versatility of this paint, thick opaque washes can be applied along with thin transparent ones, giving the work a variation of depth and structure. Experimentation is always open with this medium and one should never be afraid to try new avenues of expression with it.

Acrylic is considered a permanent paint and dries to a plastic film that is flexible and resistant to moisture and weather changes. It withstands temperature changes and will tolerate extremes better than oil. Acrylic dries with a film that is stronger than other media. Because of this film, acrylic does not chip, peel or become brittle. The crackling that can occur in oil paintings with age does not happen with acrylic. Tests over long periods of time also show that acrylic does not shrink or lose color. Note — once acrylic has dried on your clothes it usually cannot be completely removed. Be sure to wear old clothes when using acrylic.

Compared to other media, acrylic dries very fast and even thick layers of paint, as shown here, will dry quickly. A painting will normally dry the same day it was painted. This quick drying time can be an advantage when painting multiple layers of glazes. They do not have the long waiting periods

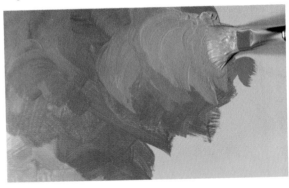

for drying time as with oil. Since acrylic is insoluble in water when dry, layers of wet color can be painted over one another as soon as they are dry — a matter of minutes in many instances. There are some solutions available that will retard the drying, but as described later, these must be used with care.

Acrylic is an exciting medium and requires only a small amount of additional mediums and tools compared to oil painting. No matter what medium you paint with now, you should try acrylic. I think you will find a new door open to a wonderful painting experience. Again, don't be afraid to try new approaches with this or any other medium. Play with acrylics and make them work the way you want. This is an individual medium and it can be great fun. I hope you enjoy acrylics as much as I do.

ACRYLIC BRUSHES

All of the brushes and tools shown in the watercolor section can be used with acrylic. In most cases, they will perform the same when acrylic colors are used thinly, as in watercolor. Some of them may also be used to paint the acrylic thickly, similar to oil techniques. A word of caution: acrylic can destroy a natural hair brush very quickly by clinging to the surface of the hair and setting. It is almost impossible to remove and can end the life of a very expensive red sable brush.

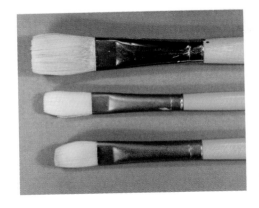

There are, however, brushes designed especially for acrylic. These synthetic brushes are made mostly of nylon. Some are fine, like natural soft hair; others are made in varying degrees of coarseness to resemble natural bristle hair, as shown in the photo. These brushes are available in all styles and sizes.

A watercolor or acrylic painter does not have to limit himself/herself to the brushes listed in catalogs for those media. Feel free to experiment and use any tool that will do the job needed, no matter what medium the tool is designed for. The only caution is that any tool used should never contribute to the weakening of the painting structure or chemically harm the pigments.

Oil painters frequently use any brush that will make the desired stroke (see *Oil Painting Materials And Their Uses*). Watercolor and acrylic painters should feel free to do the same. If a tool or brush does the job and does not harm the painting, use it! The results are what we are after. Following are some examples of various styles of brushes at work with acrylic, including some of the ones shown in the watercolor section.

Natural Hair Brushes

The construction and sources for natural hair brushes are discussed in detail in the watercolor section of this book (page 8). It is important, however, to show some of the natural hair brushes at work with acrylic paints in order to demonstrate their value to this medium. Again, I want to stress the importance of not allowing acrylic paint to dry in the natural hair brushes. The following photos show some of these brushes at work.

Here we have a natural hair sable brush being used to paint a soft, delicate glaze to create a shadow effect. This combination of napthol crimson and sap green creates a very soft greenish-grey which makes a perfect shadow glaze. In some areas the color of the glaze is more red; in others it is more green. Both, however, are in the grey range in order to work as a shadow color. The sharp, clean styling of the flat brush allows for excellent control of color application.

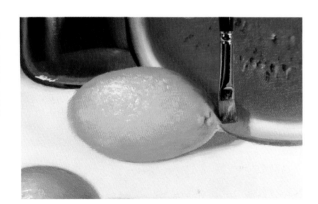

In this photo we see the natural white hog bristle in a filbert style. This brush can be used the same as with oil paints, and by capitalizing on the curved end of the brush, we make strokes that enhance the forms in cumulus clouds. This brush must be kept wet while working with acrylics as the paint will cling to the flagged ends of the hair and clog. This problem is minor compared to the benefits this brush can give to techniques and paint manipulation.

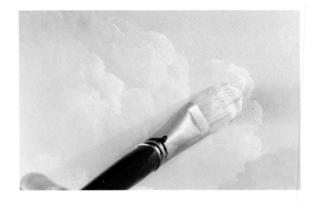

Synthetic Hair Brushes

Synthetic hair brushes, most made of nylon, have been designed especially for acrylics. These brushes come in several colors of bristles. Due to the slick sides of these bristles, acrylic paint will slide easily from the brush to the painting surface. This is also helpful in cleaning as the paint does not cling to the bristles as with natural hair, so it is easily removed. It is not a good idea, however, to allow any acrylic to dry in any type of brush.

These brushes are available in bristles that range from thin and fine to imitate the soft sable hair, to thicker and stiffer bristles that act as a natural hog bristle brush. All of these brushes work very well and are considered the "workhorses" of acrylics.

The feel of synthetic brushes is a bit different than natural hair brushes, but both are worth considering. I love the feel of natural hair brushes, but use both types in my painting. The synthetic hairs of today are so perfected that it is sometimes difficult to tell the difference by eye. Try each type and decide for yourself which you prefer; maybe you will like both, as I do.

These brushes are available in most of the same sizes and shapes as natural hair brushes.

A synthetic round brush will maintain a very sharp point and fine detail can be painted with it. It is also capable of holding a fairly good amount of paint for making larger strokes. The light highlights are being applied to this tree trunk in thin layers of color. Since acrylic dries so fast, the highlight can slowly be built up to the degree of color desired.

As you can see, this one inch synthetic is capable of pushing large amounts of paint around quickly. This is important due to the rapid drying rate of acrylic paints. Here, red and orange are being blended loosely to create a color texture and a painterly blend. If we wanted the colors to be blended smoother, a few quick strokes with a clean, slightly damp brush would do the trick.

Techniques similar to those used in tempera painting are possible with acrylics by using a pointed round. This synthetic round is placing different values of blue over one another in order to create a textured blend. From a slight distance the colors will seem to blend smoothly. By using a very tiny point and small minute strokes, realistic painting techniques can be accomplished. Since the drying time for acrylics is so short, these blends can be accomplished almost without stopping.

Combination Brushes and Acrylics

The combination or blend brushes discussed in the watercolor section of this book are also good for painting with acrylics. A few combination brushes of natural hair and synthetic hair can be used for special painting techniques that you may develop. I use these brushes for soft delicate work. But, again, never allow acrylic to dry in these brushes as the acrylic has a tendency to cling to the natural hair.

The photo above shows a combination synthetic and natural hair brush being used to paint the highlights on foam. These brushes allow for good clean control and soft blends of color. The top right photo shows a combination filbert-style brush used to create the illusion of icy snow on the boughs of a pine tree. By loading the brush on one side and placing the color up as shown, small curved strokes are placed one over the other to create the delicate effect. Bottom left shows a heavy load of color being drawn over rough watercolor paper to resemble thick boards. These are done with thicker paint than the ones in the watercolor section. Bottom right, a very thin, transparent wash of pthalocyanine blue is drawn over blue pencil lines to show the transparency of the wash.

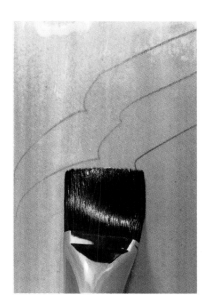

CARE AND CLEANING OF ACRYLIC BRUSHES

The cleaning of acrylic brushes is extremely important. A brush should never sit with acrylic in the bristles and especially not allowed to dry. All acrylic brushes should be washed out periodically during the painting session to remove any residue of paint that may be setting in the brush. An occasional washing also aids in keeping the color mixtures clean and uncontaminated. If a brush does sit, make sure that it is kept wet. Wrap them in wet paper towels or allow the bristles to remain submerged in water without touching anything. Do not submerge the painted wooden handle, as long soaking can cause the wood to swell. This, in turn, cracks the paint and can loosen the handle from the ferrule. When washing out acrylic brushes, use only cool or lukewarm water — never hot. Hot water will set the paint in the brush and make it almost impossible to remove. Keep the water clean by changing it often. Once the water becomes grey and slick, dump it and replace it with fresh water. This also helps to keep the brush clean.

If using any of the bamboo/reed/oriental-type brushes as described in the watercolor section, do not soak more than 60 - 75% of the hair because many of these brushes are set in water-soluble glues and binders and if soaked, the hair will fall out. Once the painting session is over and the brushes need a final cleaning, follow the instructions shown under "Care And Cleaning Of Brushes" in the watercolor section (page 24).

ACRYLIC PALETTES

The acrylic palette must be nonabsorbent or the paint will attach itself to the palette and can never be removed. Some artists use disposable waxed-paper palettes, but I find that this wastes too much paint since it is difficult to keep damp. Also, there are no barriers along the edges to keep large amounts of wet paint on the palette. The best kind, in my opinion, is the butcher's tray shown in the watercolor section and shown again here, set up for acrylic painting.

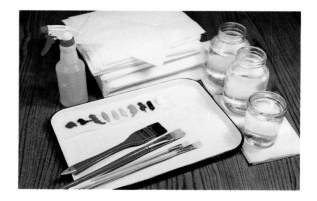

Placing a wet paper towel along the top edge of the tray will keep the paint wet longer because the towel acts as a humidifier of sorts. As the paint is used and mixed on the flat working portion of the tray, it can easily be replaced. Also, by using the open portion of the tray for mixing, the brush can be moved back and forth very quickly from mix to fresh raw color. The practice of using two water jugs as described in the watercolor section is especially important with acrylics. Dirty acrylic water tends to become slick with residue and there is little chance of keeping both brush and color clean in the same container. Once the mixing portion

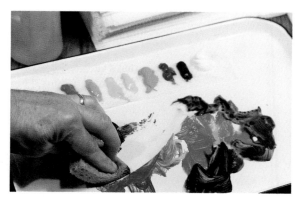

of the tray is covered with dry paint, it can be cleaned easily by wiping a wet towel across it if the paint is thin, or by a quick soaking if there is some stubborn paint left. Plate glass or any other nonporous, nonabsorbent material can also be used for a palette.

Some of the plastic watercolor palettes work very well for acrylic, too. The wells in these palettes are perfect for mixing large washes of color in. Any plastic container such as a butter tub or plastic muffin pans also work well for mixing large amounts of color. Try all sorts of sizes and shapes of palettes until you find the one that's right for you.

ACRYLIC COLORS

Acrylic colors are available in various types of containers — tubes, jars, and squeeze bottles. The tube colors are the most commonly used kind for canvas painting. This is not to say that the others can not be used as well, but, again, a caution must be raised about mixing different brands of acrylic paints without first performing a test for their compatibility. Each manufacturer has their own formulations and some may not intermix well.

A wide variety of acrylic hues are available. Most of the acrylic colors that are intended for canvas painting are the quick-drying type. There are some that have an extended drying time and, again, care should be taken when intermixing brands. Make sure you are aware of whether the mixed brands will work well together before applying them to the master canvas. The different drying times indicate a difference in formulation and one needs to be completely sure that the final product will be permanent. Also, the slower drying paints usually dry with more of a matte sheen; the quicker drying paints dry with a glossier finish.

The whole range of colors available in oils, watercolors, gouache, etc., is basically available in acrylics. However, there are some color pigments that are not manufactured in the acrylic line because they are not compatible with polymer bases; other colors can be used as substitutes.

As with oils, some colors are transparent and some are opaque; some are strong and some are weak. And, as with other media, the tinting strength of each color varies.

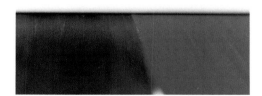

A good beginning palette should contain a warm and a cool of each primary color, a couple of earth colors, and black and white (see *Color And How To Use It* in Walter Foster's Artist's Library Series). White is a must for mixing light values of color with acrylics. But, if you use acrylics transparently as with watercolor, the white is omitted. At the end of this segment there is a list of colors by name that make a good starting kit.

A white pen was laid over these two blues showing the difference in surface gloss between fast and slow drying paint. The slower the drying, the less gloss.

In the world of acrylic color names (and other media for that matter) there are colors available from manufacturers that are achieved by making blends of the more common colors, as well as delicate colors that are obtained by special formulations of ingredients. They are all beautiful, but to name them all here would take several pages. Keep in mind that these delicate blends are obtainable in most part with a little color manipulation by the artist. Some artists do not want to bother with mixing colors, but, in my opinion, it is impossible to paint without creating your own blends and colors.

The list of acrylic colors that are available is so extensive that only the most common colors are listed here. Also, most of the manufacturers produce colors which are labeled under "house" or "proprietary" names. Good examples of this are the colors made by using pthalocyanine and manipulating the formulas. An artist can also manipulate colors to create special mixes of his or her own. By maintaining careful notes, the mixtures can be repeated easily.

Following is a list of acrylic paint colors from various manufacturers that are readily available from your local art suppliers. Those with asterisks (*) are the ones that would make a good starting palette:

Reds

Alizarin Crimson
Cadmium Red Deep
*Cadmium Red Light
Light Oxide Red
*Napthol Crimson
Napthol Red Light
Permanent Red Deep
Permanent Red Light
Red Oxide

Oranges
(Colors that are commonly referred to as brown)

*Burnt Sienna
*Burnt Umber
Raw Sienna
Raw Umber

Oranges (Chromatic)

Cadmium Barium Orange
*Cadmium Orange
Hansa Orange
Indo Orange Red
Permanent Orange

Blues

Cerulean Blue
Cobalt Blue
Manganese Blue
Permanent Blue
*Pthalocyanine Blue
Turquoise Blue
*Ultramarine Blue

Greens

Chromium Oxide Green
Emerald Green
*Hookers Green
Permanent Green Deep
Permanent Green Light
*Pthalocyanine Green
Sap Green
Yellowish Green

Yellows

Cadmium Lemon
Cadmium Yellow Deep
Cadmium Yellow Light
*Cadmium Yellow Medium
Hansa Yellow Light

Yellows (Cont'd.)

Hansa Yellow Medium
*Lemon Yellow
Naples Yellow
Naples Yellow Deep
Naples Yellow Reddish
Transparent Oxide Yellow
Yellow Ochre
Yellow Oxide

White

*Titanium White

Blacks

Ivory Black
*Mars Black
Oxide Black
Paynes Grey

Purples

Dioxazine Purple
*Permanent Blue Violet
Permanent Red Violet

Permanence/Lightfastness

The permanence of colors in acrylic painting is just as important as it is in other media. And, as with other media, the manufacturers of acrylic use symbols to describe the permanence of each color. The same coding systems described in the watercolor section (page 30) are also used with acrylic and should be taken into consideration when selecting colors to use. Acrylic is a durable paint; it withstands weather, temperature changes, moisture and humidity much better than most other media. The artist should, however, be aware of which colors are more apt to fade or those which are considered fugitive.

Color Transparency/Opacity

The following chart shows how opaque or transparent some of the acrylic colors are. Each manufacturer produces a chart indicating the exact degree of transparency for each color they make. These charts are usually available at art supply stores at no cost. If they are not available, don't hesitate to write the maker; they'll be happy to send you the information.

Opaque

Cadmium Lemon
Cadmium Orange
Cadmium Red Deep
Cadmium Red Light
Chromium Oxide Green
Emerald Green
Light Red Oxide
Mars Black
Naples Yellow Deep
Naples Yellow Reddish
Oxide Black
Raw Sienna
Red Oxide
Turquoise Blue
Yellow Ochre

Semi-Opaque

Burnt Sienna
Burnt Umber
Cadmium Yellow Deep
Cadmium Yellow Light
Cerulean Blue
Cobalt Blue
Paynes Grey
Permanent Green Deep
Permanent Green Light
Permanent Red Light
Raw Umber
Van Dyke Brown
Yellowish Green

Semi-Transparent

Carmine
Lemon Yellow
Permanent Blue Violet
Permanent Red Deep
Permanent Red Violet

Transparent

Pthalocyanine Blue
Pthalocyanine Green
Sap Green
Transparent Oxide Yellow
Ultramarine Deep

As stated above, this is just a sampling reference. Some colors are transparent enough to use in a watercolor technique. Others that are not quite as transparent can be significantly thinned down and used with success. Experiment with your colors and notice which ones are transparent and which are not. The black line exercise used in the watercolor section (page 31) is also a good reference to make with acrylics.

ACRYLIC GOUACHE

Oil and blending technique painters have had the desire to paint with artist's acrylics since their introduction, but the fast drying and curing times of these acrylics have been the source of much frustration. Some artists have added gouache to acrylics in order to slow the drying and curing times for the purposes of blending and brush manipulation and, also, for rewetting the paint before it is totally cured dry.

Gouache is an opaque water paint that is usually made with the same binder as watercolor (gum arabic), but with the addition of a white filler. It mixes well with acrylics in some cases, but one must be careful with the ratios of each. True gouache can be rewetted after it has dried.

Acrylic gouache is now on the market. It is produced with exacting formulas and meets all the necessary qualifications of fine paints. This paint was originally designed for the decorative arts market, but it is making its way into fine art and being used quite successfully by canvas painters. It has a longer curing time than other types of acrylic and dries with a flexible film. Traditional gouache becomes brittle when it dries and is very fragile; acrylic gouache is flexible and lightfast.

When painting with traditional gouache, the permanency of the colors is questionable. Also, the brittleness of gouache is an extreme problem; gouache paintings that have aged at all become fragile. But, because of the polymer, acrylic gouache dries with a more flexible film and the pigments are lightfast and, therefore, permanent. On the other hand, if one wishes to make this acrylic gouache perform like traditional acrylics, the addition of sealers and mediums will alter the chemical drying times. Acrylic gouache does not skin over like regular acrylics do. It may be reconstituted during the work period and before complete curing by misting with water or sometimes brushing with retarder medium. A number of mediums are manufactured for these paints; they are included in the section on mediums that follows.

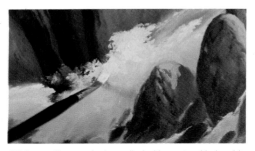

White acrylic gouache is applied with a natural hair sable flat-style brush. The slower curing of this paint allows it to be cleaned from the brush easier than regular acrylic.

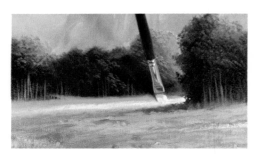

The rich combination of white and yellow creates a pathway of sunlight through the trees. The edges can be softened because of the slow curing time of the paint.

ACRYLIC MEDIUMS

Distilled Water/Water Buckets

The same rules of clear and clean water that apply in watercolor painting apply in acrylic painting. It is always wise to use the best and purest ingredients available (see "Pure Distilled Water" on page 33, and "Water Buckets/Containers" on page 25).

Diluting Acrylic Paint

When using acrylic paint, the most important rule as far as brush care is concerned is to wet the brush before dipping into the paint. Never dip a dry brush into acrylic paint. This is not only harmful to the brush, but it makes the paint very difficult to control. It would be like serving mashed potatoes with a broom. Wetting the brush sets the bristles so the moisture holds the shape of the brush and allows the paint to slide out of the brush easier.

The emulsion becomes thinner as more water is added to the paint. By adding water to some transparent colors we can use watercolor techniques to apply the paint. Remember, however, that watercolor is designed to be used thinly, but the more water we add to acrylic paint, the weaker the bonding agents become, resulting in less adhesion to the painting surface. Also, unlike watercolor, acrylic is not removable when dry and cured; it cannot be rewetted as watercolor can. The effects look almost the same, but the technique varies a bit. I am not implying that overthinning will destroy the painting, but I feel that this is important for the artist to know and keep in mind when diluting the colors. Some colors dilute more evenly than others.

The same method of cleaning and clearing of brushes discussed in watercolor section applies here; but. with acrylics, we might wish to use three water containers — two for cleaning the brush and one for picking up fresh clean water to be mixed with the paints. Acrylic paints can also be diluted by adding specific mediums that are made especially for that purpose. Some of these mediums are made of the same acrylic emulsion that the colors are made of. The following mediums have been designed specifically for use with acrylic paints.

Gloss Medium

Gloss mediums are made from the same acrylic emulsion that is used in the paint. It has a slight milky look to it, but it dries perfectly clear. This medium is used for thinning the paint while still maintaining the gloss. It aids in the flow and bonding of colors and is excellent for making thin color glazes to be applied over other colors or to tint an area. Numerous glazes can be applied over one another using this medium. Its fast drying assists in the tedious art of glazing. This medium is sometimes used as a "separator" coating (see "Isolating Varnishes" in *Oil Painting Materials And Their Uses*). This application creates another layer of transparent emulsion and, therefore, adds to the

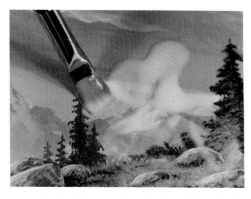

thickness of the painted surface, giving the illusion of more depth. This medium is also thinned with water and permanent when dry. Gloss medium is packaged in bottles of various sizes. It is available from most manufacturers.

Matte Medium

Matte medium is manufactured the same way that gloss medium is except the makers have added an ingredient that causes it to dry to a soft satin sheen. It can also be mixed with gloss medium to obtain a shine somewhere between the two. It is used for the same techniques as gloss medium, but one must realize that the same water-clear look will not be achieved when using matte mediums. This is not to say that these mediums alter the color, but to point out the effect that matte has on the painting when it is viewed next to a glossy one. Some people do not like shiny paintings, so matte medium is just the thing. Matte medium is packaged in bottles of various sizes and is available from most manufacturers.

Gel Mediums/Transparentizers

Gel mediums are similar to gloss mediums except they have more body and are much thicker in consistency. When dry, some are transparent and clear, some are opaque. Gels are used mostly to create impasto effects on the painting. Some gels are milky, but they dry completely clear. They hold their texture when dry and are water resistant. Transparent gels increase the transparency and gloss of the paint even though they will hold the texture created by its thick consistency. If one wishes to create brush strokes on the painting, the gel medium will dry, maintaining the original strokes and textures. Gels may be thinned with water, but are usually used in the original paste/gel form. When mixed with acrylic, gel makes the paint a bit thicker, similar to the consistency of oil paint. It handles more like oil paint which is preferred by some painters. Gel is available in tubes, plastic bottles and jars of varying sizes.

Modeling Paste/Texturing Paste

Modeling and texturing pastes are thick acrylic emulsions that have been mixed with a whiting such as marble dust. They will bond to just about anything that does not have a waxy or oily surface. These pastes can be used to create textures on the primed surface. They can also be used to create three-dimensional forms on the painting surface by applying the paste in layers until the desired form is obtained. While wet, this paste can be molded and formed; when dry it can be cut, sanded and carved. Color can be added to the paste or can be applied to the surface after the paste has dried. Most pastes are white when wet, but become translucent when dry.

Retarder

There are several retarders on the market designed to slow the drying time of acrylic paints. These retarders work well when used with care, but too much retarder in the paint can create uneven drying problems and one can lose track of where the retarders were used in the process of painting. Retarder can be added to the paint on the palette or painted onto the painting surface then the color painted into it. The length of drying time depends on how much retarder is added to the paint. If you use a lot of this medium, take care not to overwork the painting. When we allow ourselves more time to "play" with the paint, the tendency to overblend and "pick" at the painting develops. Some palettes can be kept wet for several hours by using this medium. Soft blends, reminiscent of oil paints like the ones shown here, are possible. Manufacturers include warnings against using too much retarder, especially with particular colors. Retarders are available in tubes, plastic bottles and jars of different sizes.

Wetting Agents/Flow Mediums

Several manufacturers offer wetting agents for use with acrylics. These mediums increase the fluidity of the paint and eliminate brush marks. In many cases they also increase the paint's bonding ability to some surfaces. These agents should be used sparingly and with care. Several drops in the medium or paint will usually suffice. They are thin in consistency and mostly clear. Follow the instructions provided with the solution and there should be no problem.

Special Effects Mediums

There are a number of mediums designed to create special effects. One type is used alone as a glaze to create a crystallized glossy effect over an area. Another kind turns the paint into a fabric paint so the paint becomes permanent and washable when pressed according to the instructions. Another, when used with acrylic gouache,creates a crackled effect resembling a very old painting. There are a number of other special effects mediums, and the list will continue to grow as the paint industry searches to improve the old products and discover new ones.

ACRYLIC VARNISHES

Nonremovable Varnishes

Many people wonder why an acrylic painting should be varnished at all since it can be cleaned when dry, but all paintings must be protected from dirt, especially home cooking oils and fireplace smoke. A varnish will protect the painting by acting as a shield. Varnish also controls the evenness of gloss or sheen and enhances the colors to suit the artist.

The acrylic gloss and matte mediums previously discussed are often used as a final varnish for acrylic paintings, but these mediums cannot be removed for restoration purposes without causing damage to the work because they actually become a part of the painting. They are permanent and can be applied thinly over a final painting to give the appearance of an overall varnish. They can also be used as a separator varnish for deep glazing techniques.

Polyurethane Varnishes

Water-soluble polyurethane varnishes work well for a final protective coating on an acrylic painting. These varnishes are permanent. They can also be used as an intermediate glazing varnish (separator coat). They are available in different finishes, from high gloss to matte.

Removable Varnishes

Protective varnishes that can be removed for restoration purposes (like damar varnish for oil paintings) are available from several manufacturers. The varnish needs to be removable so that a conservator can get to the original paint for restoration or repair. If a painting becomes damaged and the repairs are made over the protective final varnish, the repairs will be on a different level than the original paint with the varnish in between. Also, true color control is very difficult to accomplish when the varnish is in between. Removable varnish is made of pure acrylate resins dissolved in a solvent such as white spirits — a petroleum distillate known as mineral spirits. It is non-yellowing and can be removed easily with mild solvents without causing damage to the painting. These varnishes are available in both gloss and matte finishes. They come in bottles of various sizes.

ACRYLIC VARNISH REMOVERS

These are a mild solvent that will remove both gloss and matte removable varnishes. They must be used with care so that no damage is caused to the acrylic colors underneath. Each manufacturer produces a remover that works best with their products, or they provide instructions on what to use and how to use it. Care must be taken to remove the varnishes a little at a time; do not try to take the varnish off in one swipe or it might result in the removers attacking some of the painting. Varnish removers are available in bottles from 2 fluid ounces and up, depending on the maker.

DAMAR VARNISH

Damar varnish is a resin that is generally used as a protective removable varnish for oil paintings (see *Oil Painting Materials And Their Uses*), but some artists use it over acrylic paintings because of the rich depth and gloss it provides. This varnish is prone to cracking with age if not supported properly, and in my opinion, it should be left to the medium for which it is best suited — oils. This varnish can be removed with turpentine and petroleum solvents for restoring purposes, but these harsh solutions might damage an acrylic painting.

ACRYLIC PAINTING SURFACES

Watercolor Papers

The watercolor papers, boards, etc., that are described in the watercolor section can all be used with acrylics. Each will make a successful support for a number of acrylic techniques. Acrylic is so versatile that it will adhere to just about any surface that is slightly porous and has no wax or oil in or on it. So, in addition to the ones shown in the watercolor section, here are several others that are considered important supports for acrylic paints:

Illustration Boards

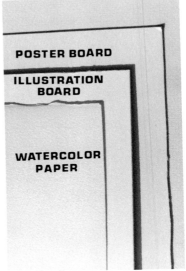

Illustration boards are made by mounting fine grades of paper onto stiff boards. These boards can be used for pencil, watercolor, ink, or acrylic. They have a paper mounted on the back to prevent warping and they come in several textures as described under "Surface Textures" in the watercolor section (page 36). Acrylic paint may be applied directly to the surface as is, or they can be treated with a priming or underpainting first (see "Preparing Painting Surfaces," page 56). These boards are available in different sizes and weights, depending on the manufacturer. It is often more economical to buy a large size and cut it to the desired sizes with a mat knife.

Poster Boards

Poster Boards have a smooth surface that has been prepared for show card and tempera colors. These boards are usually thinner and less expensive than fine quality illustration board. They are not usually used for serious acrylic painting, but many artists use them for quick idea sketches. A large sheet of board cut into small thumbnail sizes is handy for this purpose. The surface of poster board will not tolerate erasures and will show marks if rubbed with any pressure. Available in various sizes and weights, these boards can be useful for planning stages and sketches, but again, they are not considered a permanent surface for serious works of art.

Plywood Veneer Panels

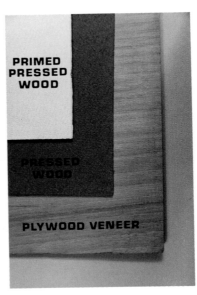

A smooth, thin veneer of quality hardwood glued to a plywood base makes a fine painting panel. These are more readily available and less expensive than solid wood boards. Care must be taken to purchase a plywood of high quality to insure the layers of glue and board are bonded properly. These panels are available from lumber yards in thicknesses from 3/16" and up. The most common is 1/4". A normal full sheet is 48" x 96", and for a small fee most lumber yards will cut these to specified smaller sizes with precision. These boards may be used in the same manner as hardwood boards, but care must be taken to seal the cut or raw edges from moisture or the layers may separate.

Pressed Wood Panels

There are several types of pressed wood panels available, but the best types for painting are those containing no glue. These are manufactured by pressure and steam and are generally available with one smooth side and an imprint of screening on the other. Panels with two smooth sides can be ordered specially from your lumber yard. They are a little more expensive, but worth it as the lint factor is minimal.

Pressed wood panels are available "tempered" and "untempered." The tempered panels are impregnated with oil and should not be used for acrylic priming or painting. They are, however, suitable for oil painting. The best for acrylic and general painting is the untempered as acrylic gesso will adhere to its oil-free surface without chipping or peeling.

These panels are available from your local lumber yard and, again, for a small fee they will usually cut the large panel into the sizes needed.

Pressed Wood Panels (Ready-To-Use)

Ready-to-use, commercially prepared pressed wood panels primed with gesso are available in a variety of sizes from art supply stores. The surface is extremely smooth for detail work since the priming has been applied by spray or roller. These panels are priced about the same as mid-quality, ready-to-use cotton canvas and are very handy for student work and for those without the facilities to spray their own panels. Caution: determine what the panels are primed with before you purchase them. If it is an oil-based primer it cannot be used for acrylics. If it is a true gesso it will be more absorbent than acrylic gesso. Both types of gesso primings are suitable for acrylics.

Solid Wood Boards

Acrylic paint will adhere to fine hardwood boards that have been cured and are thoroughly dry. There is a special feeling to painting on a hardwood surface — the paint seems to flow naturally. Some soft woods will work well also, but due to the absorbency of some grains, a sizing must be applied before the paint will behave as desired. Colors will sink in and appear dull if the surface has not been treated. All-purpose sealers are available that can be used in this case. These sealers will stop the penetration into the board, yet maintain the adhesive qualities desired in the paint.

Wooden boards can be ordered from various suppliers or lumber yards. Boards such as oak, birch, and walnut are expensive, but they make a nice painting surface when sanded and treated.

Fabric Supports

Fabric supports are available in rolls and ready-made forms. They are rectangular, square, oval or circular. Linen and cotton are the two fabrics that have proven to be the best supports for oil and acrylic paints. Both are extremely fine surfaces to paint on. Acrylic can be painted on most any fabric without priming, but it is better to prepare the surface properly to insure longevity of the painting and also to use a high quality fabric that will not disintegrate easily.

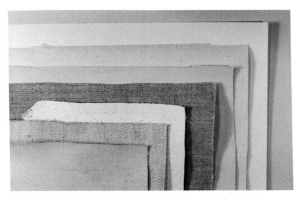

From top to bottom: paper painting pad, unprimed cotton canvas, the same canvas with polymer gesso prime, unprimed linen canvas, the same canvas with polymer gesso prime, unprimed linen, the same canvas with polymer gesso prime.

Linen

Linen is available in a number of textures from very smooth (used for portrait and detail techniques) to very rough. These textures are known as the "tooth" of the material. Rough material has more "tooth" than smooth material. Linen is far more expensive than cotton and is often primed by hand. It is well worth the extra cost, however, as paintings seem to have a richness when painted on linen. Linen is available in rolls of different widths and lengths and comes unprimed or single- or double-primed with polymer gesso or oil. Be sure to use only those primed with polymer gesso when using acrylic paints. Linen is also available in ready-made canvases of various sizes.

Cotton

Cotton is available in rolls, stretched on wooden stretcher bars, or glued onto cardboard-type surfaces and folded over the back in the form of canvas boards. Cotton is available in a wide variety of textures and qualities. A good standard of quality is any good cotton duck from a known mill. Cotton is inexpensive and usually primed with polymer gesso through an automatic process. Make sure the canvas you are purchasing for use with acrylics does not have an oil primer on it.

PREPARING ACRYLIC PAINTING SURFACES

Acrylic is very adhesive and will adhere to almost any porous surface. Unlike oil, it can be painted directly on cloth surfaces without sinking into the material and rotting it in the future. Acrylic actually acts as a preserver. It will not, however, adhere to oily or waxy surfaces, slick surfaces such as polished metal, or enamel types as shown in the palette section, or glass. The acrylic might stick to these surfaces for a while, but will be subject to peeling in the future.

True Gesso/Polymer Gesso

True gesso is made by mixing whiting, chalk or plaster of Paris with a glue or gelatin water-soluble binder. When dry, it is absorbent and will draw moisture away from any paint that is placed on it. True gesso is perfect for painting with tempera paints. It is a bit too brittle for surfaces such as canvas, but acrylic or polymer gesso is more flexible and bonds perfectly, thus creating an ideal painting surface for acrylic colors. Polymer gesso is a mixture of the same polymers that make up the paint colors, but it is combined with titanium and is a different consistency. It is thinned with water just as the paints are, but care should be taken not to overthin and lose the quality of the gesso.

Acrylic polymer gesso can be painted directly onto any acceptable painting surface such as those described above without worrying about sizing as we do with oil paints. After the acrylic gesso coat is dry, modeling paste can be used for even greater textural effects.

Always purchase an acrylic gesso for priming acrylic painting surfaces. You can then paint on almost any semi-porous surfaces, including concrete and other alkaline surfaces, if desired. Acrylic gesso is available in jars, cans and plastic containers of various sizes. It also comes in black and a variety of colors.

By applying acrylic gesso in a variety of thicknesses and strokes we have created an interesting primed surface to paint on. In many cases, the texture adds greatly to the painting.

PRIMING METHODS

Acrylic Gesso

Acrylic gesso is the conventional primer for painting on panels. It can be applied with a nylon brush, a paint roller, a sponge, or a putty knife, or sprayed on with an air pressure paint sprayer. When using a sprayer, the gesso should be thinned with a little bit of water so it will pass through the spray gun evenly. However, do not overthin to a watery consistency as this will weaken the binder and ruin the hiding power of the titanium pigment. Three coats of gesso are usually sufficient. A light sanding between each coating with a wet-or-dry sandpaper of 800 grit used in a dry state creates some tooth for the next coating to adhere to and also removes any lumps that might result from the gun. Acrylic gesso can be used without sanding because it dries with just the right surface to accept acrylic paints. Sanding is used mostly when gesso is applied with a sprayer because of the smooth surface it creates.

Whether using a sprayer or a brush it is wise to alternate the stroke direction on each application. For instance, apply the first coat with a horizontal stroke, apply the second coat using vertical strokes, then apply the third coat with the horizontal strokes of the first coat. The brushed surface will have a fine linen canvas look even though it may be painted on a pressed wood panel.

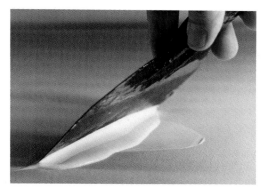

Other methods of application can also be used. Applying the gesso in a random pattern of strokes produces an interesting background that will often enhance the subject matter. A loose, carefree surface can sometimes give a fresh appearance to the painting. Applying gesso with a putty knife fills the cavities in the canvas and produces a smooth painting surface, yet still has tooth. Start in the center and work to the outer edges in a circular pattern.

Acrylic Mediums as Primers

If the surface pattern (such as a beautiful wood grain) is to become a part of the painting, gesso cannot be used to prime the surface because its white pigment would cover the pattern. In these cases, acrylic gloss medium or matte medium can be used as a sealant. When thinned with water they make a good sealer and create an excellent painting surface. All-purpose sealers for wood, metal and glass are also available for these cases. These sealers are pure acrylic with remarkable adhesive power and are thinned with water.

Another wonderful surface for acrylics is cold-pressed illustration board that has received a priming of acrylic gesso or medium. The illustration board surface is receptive to both very smooth or roughly textured finishes. Many serious works of art have been accomplished on this type of surface. The methods of applying the gesso or mediums on the board are the same as previously described. But, make sure you seal the edges of the board against possible water absorption or warping and peeling may occur. Try it — it's a fun surface!

Toned Surfaces

As stated before, gloss or matte medium may be used as a sealer or priming coat when the support has a color or design that enhances the painting. If, however, another color is desired, color can be applied as a color basecoat. If a very dark undercolor tone is desired, the acrylic paint itself can be used for this purpose.

An interesting toned surface is achieved by thinning acrylic paint to a glaze consistency and washing it over dried gesso. This produces an overall color tone with an interesting texture and grain. The richness of color is obtained because the light rays strike the white gesso and are reflected back to the eye through the transparent color glaze.With this technique, we are looking into the paint, not at it.

Try many such exercises. Acrylic is a fun medium; it has a wide latitude for experimentation.

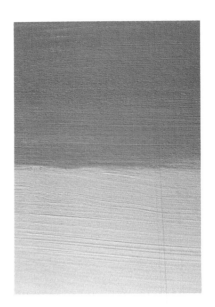

OTHER TOOLS

Acrylic can be applied and manipulated with a number of objects. And all of the items shown in the watercolor section can be used with acrylic, and those shown here can be used for watercolor. Some tools lend themselves better to one type of paint or the other, but most are interchangeable.

Maulsticks

A maulstick is a long, lightweight stick used to steady a painter's hand. Holding one end of the stick, the other end is laid on the top edge of the canvas or drawing surface and the artist uses it to steady the painting hand. The tip can be wrapped with a soft material to place it on the face of the work, if needed. Maulsticks are available in metal telescoping tubes (similar to a radio antenna) or solid wood. A hardwood dowel stick also works well.

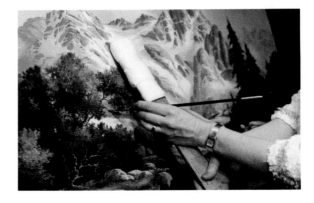

Dabber

A dabber is made by cutting soft cotton material (such as t-shirt material) and filling it with cotton. By gently and quickly tamping the dabber into two different colors, large, gradual blends are created. Notice how the texture of the cloth is imprinted in the blend. Many varieties of patterns are possible depending on the type of cloth used.

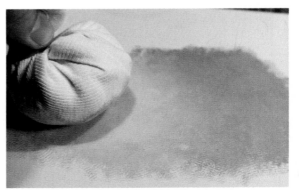

Bridges

A bridge is a wooden, plastic or metal tool that holds the painter's hand away from the surface, yet gives the hand access to all areas of the painting. By placing pieces of material at each end to elevate the long span of the bridge, the artist can work on a tabletop and never touch the wet painting. Two books and a yardstick will work in a pinch, but the more refined and crafted bridges are easier to handle and well worth the price. With a little work you can build one of your own design and specifications for the particular type of work you are doing.

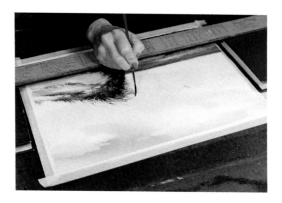

Sponges

Natural and synthetic sponges can be used for both watercolor and acrylic painting. They are wonderful painting tools. There are several types and sizes to be used for various jobs: wiping up or lifting color, blotting, applying water as in stretching paper, stippling different textures, etc. Natural sponges have a more silken feeling and are not as abrasive to the paper surface as some synthetic ones are. The sponges shown are the most commonly used types: (A) white silk sponge, (B) elephant ear sponge (so named because it resembles an elephant's ear), (C) rectangular synthetic sponges of various thicknesses.

The silk sponge can absorb a great amount of liquid, as seen here. It can be used to pick up color, carry water, stamp textures, or apply colors.

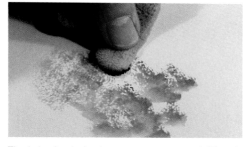

The holes in elephant ear sponges vary and different textures can be obtained by patting paint onto the painting surface. They are a very valuable tool.

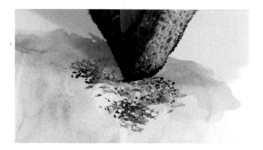

The corner of a synthetic household sponge can be used to paint leaves, foliage of various forms and other textures. Patterns are printed by gently tapping color onto the surface.

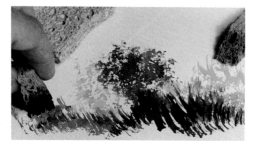

By cutting a synthetic sponge into a wedge shape as shown, we have created a painting tool that will stamp or draw patterns onto the painting surface.

Sponge Brush

An inexpensive sponge brush is a handy tool in many ways. It can hold a lot of paint or water and because of its shape, it can be used to apply or remove paint and water in a more controlled manner than many other sponge forms. The straight, wide tip can also be used to create uniform shapes. Sponge brushes can be obtained at local paint stores.

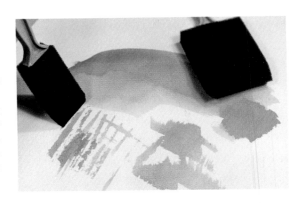

Paper Towels and Tissues

Paper towels and tissues are mainly used to blot out color or to create texture. Facial tissue usually has a finer texture than paper towels and will create a more delicate pull-away of paint. Both are great for particular purposes. Notice the beautiful pattern created by pressing a crumpled facial tissue to the paper.

Toothbrushes

Toothbrushes have stiff bristles that can be used for scrubbing out color or creating rough patterns by stamping on the painting. They can also be used to splatter paint by drawing a finger across the bristles, as shown here. Care must be taken when doing this, however, as it is difficult to control the splatter.

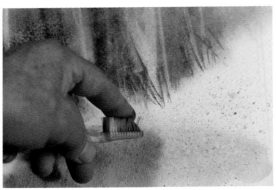

Razor Blades/Craft Knives

Single-edge razor blades and craft knives are very useful. They can be used to scrape away dry paint to create certain effects. A broad scraping can be used to create textures resembling granite rock surfaces; a number of sharp lined streaks across a surface creates the effects of rain. Many other effects are possible, too.

Liquid Masking Solution

Liquid masking solution is basically liquid rubber which often contains a coloring ingredient to make it more visible. It is applied to areas of the paper where color is not wanted. When allowed to dry for a few minutes the rubber seals the area, allowing watercolor to be painted over it without touching the paper. It is great for highlights or for keeping an area clear while painting large washes. After the color has dried, the solution can be removed easily with a rubber cement pickup or by rolling it off with your fingers. Soak your brush with liquid soap before using these solutions as they can ruin a brush quickly. The soap allows for easy cleaning of the brush.

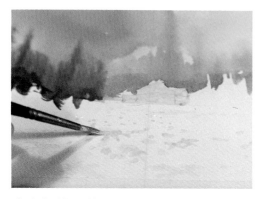

Apply liquid masking solution with a pointed brush. Let the solution dry and then paint the background color over the area.

Once the paint has dried, the liquid masking solution can be removed with a rubber cement pick-up leaving the paper clear for another color, as in the field of flowers.

Tape

Transparent tape is good for creating sharp edges or to keep an area clean and clear of paint. After an area is painted around the tape, it is removed, leaving a clean section. It is best to use the edge of the tape if possible. Try to keep cutting to a minimum because too deep of a cut with a knife can cause damage to the paper which will absorb paint.

Wax

Paraffin wax can be pressed onto the desired areas of a painting surface where it will repel any watercolor painted over it. Once the painting is dry, the wax can be removed by placing a soft absorbent tissue over it and gently pressing with a warm iron. The tissue absorbs the melting wax, leaving the area clear and clean. It is available in chunk or stick forms.

Table Knife

The tiny, serrated edge of a table knife will create very interesting patterns and textures when pressed and pulled lightly through wet acrylic or watercolor paints. Care must be taken to hold the knife close to a fifteen degree angle so as not to tear the paper. The harder the pressure, the more paint the knife will remove.

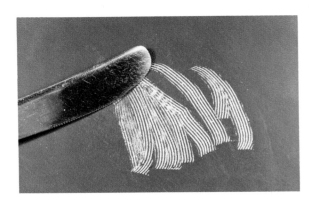

Salt

Table salt is often used by watercolorists to create interesting effects that resemble snow. By tilting the painting, the flow can be controlled, depending on how much of an angle is used. This effect is also used for background areas. Do not overuse this technique because the residue left by the salt can affect the paper over time.

Hair Drier

A hand-held hair drier is a very handy and useful tool. The warm air will accelerate the drying time of both watercolor and acrylic. Care must be taken not to let the surface become too hot or to allow the force of the air to move the paint in any way unless special effects of runs are desired.

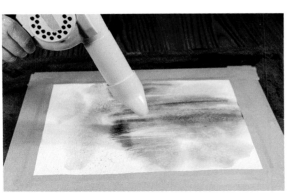

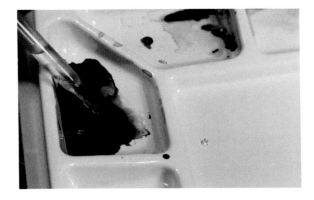

Eye Dropper

An eye dropper is used to place drops of fluid into the paint. At times it is difficult to add the right amount of liquid to an area with a brush. The eye dropper allows us to do this, as well as count the exact amount of fluid being added. This is especially good for adding retarder to acrylics. We can then repeat the exact mixture, if needed.

Aluminum Foil

Tapping crumpled aluminum foil into wet acrylic paint creates a pattern that resembles some verde antique marble or other rock textures. Aluminum foil can also be used with watercolor, but care must be taken not to mar the paper surface with the rough foil.

In this photo, the foil is repeatedly dragged in a direction that leaves a texture resembling grasses, fur, etc. Waxed paper can also be used for similar effects. Other effects are possible by experimenting with different folds and strokes.

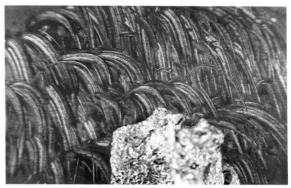

Old Brush (Bright)

An old, worn-out brush is a very valuable tool. Here, a soft hair bright is being used to create a multitude of textures. The fact that the bristles in the brush are spreading from use and neglect makes it a great texturing tool. Never throw away an old brush. Keep them as specialty brushes for grasses, fur, bushes, rock texturing, etc.

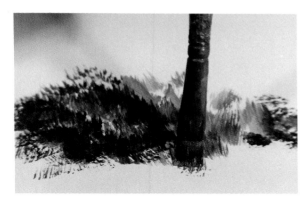

Old Brush (Round)

We would never consider treating a new brush like this, but twisting and pressing an old, worn-out round brush will create many useful textures. Notice the variety of textures shown here, and the twist of the brush. Many more are possible by turning the brush in different angles.

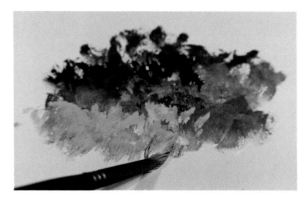

CLOSING THOUGHTS

Watercolor and acrylic paints are extremely versatile. They can be used alone, with one another, or with a number of other media. Both make a fine underpainting for oils. And, since acrylic can be applied to a painting surface with little or no texture, very colorful and detailed underpainting layers are possible. Oil paints can then be applied over the acrylics to enhance color, texture, detail, etc. Thin layers of transparent color glazes can be applied over one another until the desired depth and blend of colors is achieved.

The painting shown here was done on a pressed wood panel. The surface was prepared with a smooth, sprayed coating of polymer gesso and then sanded with 800 grit wet-or-dry sandpaper. The underpainted shapes and masses were accomplished with burnt umber, ultramarine blue, yellow oxide and titanium white acrylic colors. The details of the animals, the foreground and the background were painted in a series of glazes using burnt umber, burnt sienna, naples yellow, permanent blue, manganese blue, alizarin crimson and titanium white oil colors. Since the fur of an adult seal is smoother and less detectable than that of some other animals, the value and color changes were painted in a light and delicate manner.

Since acrylic will adhere to any surface that is porous and slightly absorbent, a great number of painting surfaces can be used. Each surface selected should be prepared properly, as previously discussed.

In closing, I would like to say that I hope the information in this book is helpful and that it will become a valuable reference to assist you in the art of watercolor and acrylic painting. I wish you all the best in your drawing and painting.